MUNCH

MUNCH

John Boulton Smith

with notes by James Malpas

Phaidon Press Limited
140 Kensington Church Street, London W8 4BN

First published 1977
This edition, revised and enlarged, first published 1992
Second impression 1993
© Phaidon Press Limited 1992

A CIP catalogue record of this book is available from the
British Library

ISBN 0 7148 2732 0

Printed in Hong Kong

The author and publishers would like to thank all those museum
authorities and private owners who have kindly allowed works in their
possession to be reproduced.

The author wishes to acknowledge his debt to writings by Henning
Gran, Reinhold Heller, Ingrid Langaard, Johan H. Langaard and
Reidar Revold, Nic Stang, and to publications of the Munch-Museet,
from which quotations have been drawn. Many of their publications
are listed in the bibliography.

Cover illustrations:
(front) *Madonna*. c.1893. (Plate 22)
(back) *Evening on Karl Johan Street*. 1892. (Plate 13)

Munch

Edvard Munch is the only Scandinavian painter to have been recognized internationally as a great modern master. This recognition was achieved first in Germany, then in Scandinavia and Central Europe, and has rested largely on his importance in the growth of Expressionism and as a pioneer of modern printmaking. In fact his range of style and subject is greater than this might suggest. Throughout his career ran the desire to communicate to a public statements of a psychological or philosophical nature about mankind. To this end, mural decoration became an aim of increasing importance to him, as also did printmaking with its possibilities of wide distribution. But his mastery in other fields is also important, covering portraiture, landscape painting, scenes of working life, and subjects inspired by literature. Yet – despite his determination to communicate with a public (confirmed by the exceptionally long list of his exhibitions) – he was a highly subjective artist who believed that his motifs should be drawn from his own experiences. Throughout his life Munch kept up a wonderful series of self-portraits and it is instructive to compare how he saw himself at thirty-two (Plate 1), forty-six (Plate 2), and seventy-eight (Plate 3). However, although his art is so autobiographical, its inspiration shows frequent similarities with that of his contemporaries; introspection was popular among *fin-de-siècle* artists, especially in northern countries. Moreover his idiom would hardly have crystallized in the way it did without the example of French Post-Impressionism.

Munch was born in 1863 into a professional family, which had included an artist, a writer, a bishop and a brilliant historian. His father was a doctor and, although his practice was not very lucrative, the home was a united and cultured one. Tragic illness struck early. Tuberculosis killed Munch's mother when he was only five, and his sister Sophie nine years later. His brother Andreas was to die at thirty, while another sister, Laura, later became mentally ill. The artist grew up afraid of illness, and fearing that he came of tainted stock: 'Illness, insanity and death were the black angels that kept watch over my cradle and accompanied me all my life'. His mother's place was taken by her unmarried sister, Karen Bjølstad, who became the centre of the household, and encouraged the boy's artistic talent. After his wife's death, Dr Munch became more gloomy and puritanical, and a rift developed between father and son. Yet Edvard sincerely loved his father, and was badly disturbed when he died. Although the pattern of his life was to become so different, Munch retained a strong sense of family. He was well aware how much his art owed to this background.

After a false start as an engineering student, Munch entered the School of Design in Oslo in 1881. His earliest paintings are small, tightly-drawn studies from his home or Oslo scenes, which hardly indicate the scale of his potential talent. But development came quickly. *From Maridalen* (Plate 4), of 1881, already shows a more

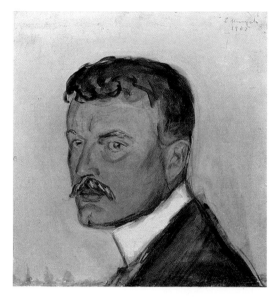

Fig.1
Self-portrait
1905. Gouache.
Nasjonalgalleriet, Oslo

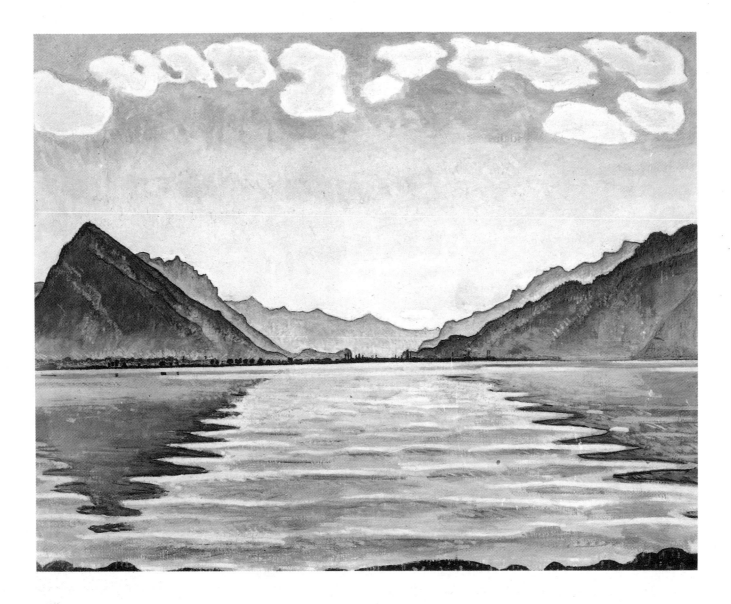

Fig. 2
Ferdinand Hodler:
Lake Thun
1905. Canvas,
80.2 x 100 cm.
Geneva Art and History
Museum

relaxed naturalism, while by 1884 he could be brilliant and atmospheric on a larger scale with *Girl on the Edge of the Bed* (Plate 5).

The Oslo (or Christiania as it was called until 1925) of Munch's youth was still a small, rather provincial town, firmly bourgeois and Protestant in its way of life. Art patronage was very limited, and most artists and writers of exceptional talent worked abroad. But the 1880s were to see many changes. More artists now started to return and settle in Norway, after completing their studies abroad. This led to innovations in the country's artistic life, notably the inauguration of the Autumn Exhibition, Norway's principal officially supported open exhibition of the year. Moreover, the spirit of National Romanticism, which had dominated so much nineteenth-century Norwegian art, was now fading, and being replaced by the new Realism from France. Artists like Bastien-Lepage and Manet, Corot and Daubigny, became models for the younger painters, Flaubert and Zola for the writers. Artists also brought home with them the habits of café life and the easy moral standards of Bohemian life in Paris; the 1880s saw the growth of the Christiania Bohème, a circle named after a novel by Hans Jaeger, one of its leaders.

Jaeger attacked the accepted Christian moral code of Oslo's bourgeois establishment, and his outspoken advocacy of atheism, anarchy and free love earned him a spell in prison. Much of this appealed to the young Munch, offering an alternative to his father's puritanical values.

Advocacy of sexual freedom would have encouraged a young man as handsome as he was, but even more important was Jaeger's insistence that one's art should be based on one's own life. Although he later came to reject many of Jaeger's doctrines, the artist followed this one throughout his life. Another prominent Bohemian was Christian Krohg, eleven years Munch's senior, whose novel and painting about the career of a prostitute scandalized Oslo. He edited the circle's newspaper, *The Impressionist*, but in fact his paintings stopped short of full Impressionism. Impressionism in Norway of the 1880s meant an impressionistic Realism, rather in the manner of Manet. From 1882, Krohg gave Munch some assistance, and *Girl on the Edge of the Bed* (Plate 5) is Krohg-like in both colour and choice of subject. However, the older artist would probably have given the motif social-realist overtones, while Munch is more sensitive to the vibrations of light. Another follower of French naturalism was Frits Thaulow, who for two summers ran an open-air painting school in Norway, which Munch attended. A third artist, whom Munch particularly admired for his sensitive painterly qualities, was Hans Heyerdahl.

By the mid-1880s Munch had embraced what he called 'Impressionism and Realism', and this characterized most of his work during the rest of the decade. A short visit to Paris in 1885, where he particularly admired work by Rembrandt, Velázquez and Manet, probably strengthened this. But in 1886 he completed a masterpiece which anticipated the mature Munch, *The Sick Child* (Plate 6). The artist always regarded this painting as a turning point, and he later

Fig. 3
The Day After
1894-5. Canvas,
115 x 152 cm.
Nasjonalgalleriet, Oslo.

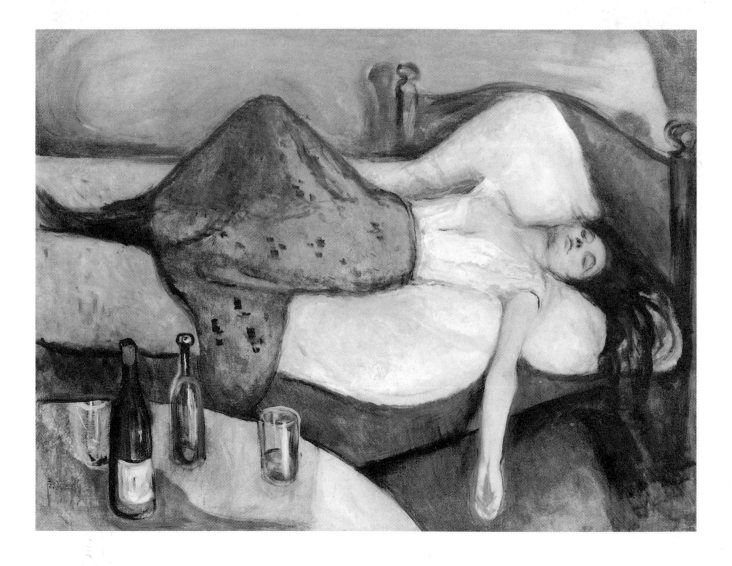

returned to the motif many times in both painting and prints (Plate 7). In it he combined a vivid visual experience (the grief-stricken face of a girl, observed while Dr Munch was attending to her small brother's broken leg) with personal memories (the death of his own sister) to express a tragedy with universal meaning – youth and death. Munch achieved this expressive concentration through simplification and technical experiment, scraping down details to focus attention on the head, the emotional and compositional centre of the picture. Today its mastery is obvious, but contemporary Norwegian critics were blinded by the revolutionary technique to the fact that the subject was a common one in the late nineteenth century. They could only see 'a disconnected collection of coloured spots … completely lacking any emotional content'. Two other important paintings of 1886, *Puberty* and *The Morning After*, were unfortunately destroyed, so we can only form an opinion from the versions he re-created in the 1890s. In contrast to *The Sick Child*, *Puberty* (Plate 8) imaginatively represents a girl's anxiety as she looks forward to life, a remarkably perceptive painting for a young man. *The Morning After* records more factually a typical scene from Bohemian life.

Munch continued to follow 'Impressionism and Realism' until 1889 when, as he wrote, he took leave of it with his large painting *Spring* (Fig. 17). On the same subject as *The Sick Child*, this picture, although masterly, is considerably more conventional, and the artist may well have regarded it as a demonstration piece in support of the application for a state scholarship to study abroad which he made that year. 1889 was a prolific year. In *Summer Night (Inger on the Shore)* (Plate 10) he turns a study of his sister into a mood picture of the mysterious northern twilight, anticipating his important theme of the 1890s: the solitary figure by the water's edge. His portraits showed remarkable psychological insight, as in *Portrait of Hans Jaeger* (Plate 14), slouched defiantly behind his drink. When Munch held his first one-man exhibition that year, his mastery was recognized by a number of prominent artists, if not by the public. His application for a scholarship was granted, and by October he was in Paris.

France was to be Munch's main base until 1892, although he returned to Norway for the summers. It was the period when he consciously started to identify the aims of his art, and to search out forms from modern painting with which to express it. He had barely been in Paris a month when he heard news of his father's death. This upset him deeply. The conflict between Jaeger's revolutionary principles and Dr Munch's intense Christian beliefs had caused disturbing differences between father and son in recent years, and there could now be no reconciliation. Munch was conscience stricken and he began to re-assess the values he had learnt from Jaeger. He began consciously to reject Realism for the ideal of an inward-looking art which, if not orthodoxly religious, was to be serious and spiritual. During the winter of 1889-90, living at St. Cloud, he noted down his new aim:

> 'No longer shall interiors be painted with people reading and women knitting.
> 'There shall be living people who breathe and feel and suffer and love.
> 'I will paint a number of such pictures.
> 'People will understand what is sacred in them and will take off their hats as if in church.'

At the same time he painted *Night in St. Cloud* (Plate 9), probably a *memento mori* occasioned by his father's death. A brooding figure sits by

the window of a dark room, while light from outside casts a cross-like shadow on the floor. The predominant colour is blue, which Munch had recently found was used by the Greeks to symbolize death.

It was probably in Nice, in winter 1891, that he wrote down an even more explicit artistic credo. After ridiculing those who can only accept naturalistic colour and who therefore are not prepared to comprehend his 'impressions', he continues:

> 'In these paintings, then, the painter depicts his deepest emotions. They depict his soul, his sorrows and joys. They display his heart's blood.
> 'He depicts the human being, not the object.
> 'These paintings are made to move people more intensely.'

And he explains how complementary colour in the optical after-image can create the essential mood:

> 'Go into the billiard room. After you have looked on that intense green table-cover for awhile, look up. How strangely red everything is! Those men you know were dressed in black now are dressed in crimson red, and the room – the walls and ceiling – is red.
> 'After some time, the clothing is black again. But if you want to paint an emotional mood like that, with a billiard table, then you must paint it crimson red.
> 'If one wants to paint the impressions of a moment, the emotional mood, then this is what one has to do.'

In another statement Munch clearly reveals his relation to Realism: 'I paint not what I see, but what I saw'. Forty years later he summed up his practice: 'I do not finish a work until I am a bit removed from the vision of it so that my memory can clarify its emotional impressions. Nature confuses me when I have it directly in front of me.'

Similar aims had been expressed by the great Romantics, and also by Munch's contemporaries. Van Gogh's description of his *Night Café*, where 'he tried to express the terrible passions of humanity by means of red and green', is close, although Munch could not have known this passage when he made his notes. They also unite him with *Nyromantikken* (Neo-Romanticism), the new Norwegian artistic movement of the 1890s. Its writers, Vilhelm Krag, Sigbjørn Obstfelder and Knut Hamsun, all friends of Munch, also reacted against Realism while retaining autobiographical sources of inspiration. In 1890 Hamsun wrote: 'What if literature were to begin to occupy itself now more with psychological states than with romances and dances ... more in keeping with the spiritual life lived by the mature modern man ... We would discover ... in short, all the subconscious life of the soul'. How like the title which Munch later gave to his *Life Frieze – Motifs from the Life of a Modern Soul*. In painting, Neo-Romanticism appeared as symbolic human dramas or mood-landscapes of the mysterious northern twilight, both basic genres with Munch.

In evolving the means to express his new programme, Munch looked around him. He had at first studied for a few months with the noted academic artist Léon Bonnat, but modern art obviously attracted him much more strongly. He would have seen mature Impressionism and its Neo-Impressionist development; his *Spring Day on Karl Johan Street* (Plate 12) shows the influence of both. Whistler was then at the height of his Parisian fame, and influences from his blue nocturnes appear in works like *Night in St. Cloud* (Plate 9), while Munch's original name, *Black and Violet*, for the standing portrait of his sister Inger (Plate 15) recalls the 'abstract' titles of the American. Munch's steep, shooting

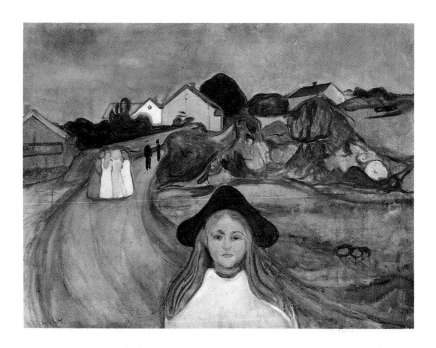

perspectives suggest that he saw works by Van Gogh, with whom he has many affinities. He must also have heard something of Gauguin, who had exhibited early work at the Oslo Autumn Exhibition during the 1880s. He probably saw works by Gauguin's followers in the 1891 exhibition of the Indépendants (which also included a retrospective show of Van Gogh's work), especially that of his Danish contemporary, J.F. Willumsen.

Later in 1891, Munch started to move towards his own characteristic style of the 1890s, with his painting *Evening*. When it was exhibited in Oslo that autumn, Christian Krohg perceptively wrote: 'Munch is … the first one to turn to idealism, who dares to subordinate Nature, his model, to the mood … It is related to Symbolism, the latest movement in French art'. The original *Evening* probably no longer exists, but surviving studies for it show use of simplified, flattened forms, and unifying flowing lines. The setting for *Evening* was Åsgårdstrand (Fig. 4), a village on the Oslo Fjord, which for many years was Munch's favourite resort, its curving shoreline providing him with a continuous inspiration. Its theme grew from his friend Jappe Nilssen's reaction to an unhappy love affair, and the motif was to recur, with alterations, as *Jealousy* (later renamed *Melancholy)*, (Plate 21) two years later.

To observe Munch's stylistic development during these three years, we can compare three paintings, all set in Oslo's principal thoroughfare, Karl Johan Street. All are characterized by long, steep perspectives, but there the likeness ends. *Military Band on Karl Johan Street* of 1889 (Plate 11) is a straightforward impression, somewhat recalling Manet. *Spring Day on Karl Johan Street* of 1891 (Plate 12) creates its atmosphere of bright sunlight with the air of Impressionism, but with a more loosely pointillist technique. But *Evening on Karl Johan Street* (Plate 13), usually dated 1892, is a mood-painting about fear, the fear of a crowd of people as the sun goes down. It is painted in his new, simplified style, and points forward to other fear subjects in the *Life Frieze*.

Munch returned home from his French studies in March 1892. During the summer he worked in Norway, and that autumn he organized a retrospective exhibition in Oslo to present his work of the past three years, although also including some earlier paintings. The reception was generally bad. The new mood-paintings, with their loose, impressionistic finish, both angered the critics and disappointed

many of his supporters among the naturalistic painters. Only a small minority admired his new direction. One who liked the exhibition was Adelsteen Normann, a Norwegian landscape painter living in Germany, who was on the exhibition committee of the Berlin Artists' Association. He invited Munch to mount an exhibition in Berlin, and the artist immediately accepted this singular opportunity.

The Germans respected nineteenth-century Nordic culture, and Norwegian painters like J.C. Dahl and Hans Gude had established big reputations there. In 1891, four works by Munch had been included in a selection of Norwegian paintings exhibited in Munich, and a critic had written: 'It won't be long before Germany is talking about Scandinavian art instead of French'. Nevertheless it is still surprising that the conservative dominated Berlin Artists' Association should have invited a young radical like Munch to hold a one-man exhibition in a city where Impressionism was still unacceptable. It is much less surprising that a storm broke in the Association when he hung his fifty-five pictures, and that they were removed a week later. However, some members including Professor Köpping and Max Liebermann, protested that a guest must have freedom of expression; they formed an opposition group within the Association, and reverberations of the affair continued for some time. But although they supported Munch on principle, they did not really appreciate his work, and only Walter Leistikow, a painter of atmospheric landscapes, actually wrote supporting his art. However, the affair was widely reported and Munch's status changed overnight from that of a struggling young painter in a small country to a notorious revolutionary in a large one. The progressive dealer Eduard Schulte arranged exhibitions for him in Düsseldorf and Cologne, and in late December Munch opened another exhibition in Berlin.

The exhibitions of 1892 enabled the artist to see the interrelation of many of his paintings and made him consider how best to make the public understand them. In March 1893, he wrote to the Danish painter Johan Rohde: 'At the moment I am occupied with studies for a series of paintings ... I believe that these ... will be easier to understand when they are all together. It (the series) will have love and death as its subject matter.' And in the 1930s he looked back: 'When they (the paintings) are shown together they strike a chord; they become quite different than when they are shown by themselves. They become a symphony. That is how I began to paint friezes.' This, then, was the beginning of the *Life Frieze*, paintings based on his subjective psychological experiences and universalized into statements about the soul of modern man. Its original core was a series entitled *Love*, consisting of six paintings, exhibited in Berlin late in 1893. It was expanded during the 1890s, and in 1902 he grouped twenty-two *Life Frieze* paintings together at his important Berlin Secession exhibition. Subsequently it was shown together on several occasions. The general theme remained constant, and some paintings were always included, but Munch from time to time varied other titles. He would always have liked to achieve a permanent public setting for the collected frieze, but this was not accomplished during his lifetime. However, in the home which he finally established in Norway, he retained a collection of the paintings, making new versions of ones which had been sold. When he exhibited the *Life Frieze* together in Oslo, in 1918, he wrote:

'The frieze is intended as a series of decorative pictures, which together give a picture of life. Through it runs the curving shore-line, beyond lies the ocean, ... and beneath the leafy trees

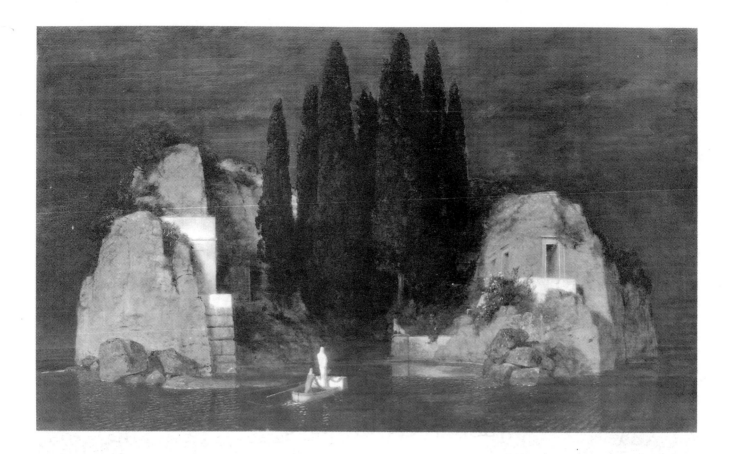

Fig. 5
Arnold Böcklin:
The Island of the
Dead
1880. Canvas.
Metropolitan Museum of
Art, New York

manifold life with its joys and sorrows is lived.
'The frieze is intended to be a poem on life, love, and death.'

During 1893, spent mainly in Germany, Munch completed the original *Love* series. The story can be deduced from the paintings. The girl waits for love in the summer night. Love fuses woman with man in a kiss. The pressure of woman's love causes the man pain. She, however, achieves ecstatic fulfilment. But the climax is followed by jealousy, and love finally disappears in terrifying despair.

Munch made a number of versions of the motifs; a selection is reproduced here. The titles used today are frequently different from the original ones; the present titles, with the 1893 titles in brackets, are as follows: *The Voice (A Summer Night's Dream)*, (Plate 20); *The Kiss (Kiss)*, (Plate 19); *Vampire (Love and Pain)*, (Plate 18); *Madonna (The Face of a Madonna)*, (Plates 22 and 23); *Melancholy (Jealousy)*, (Plates 21 and 29); *The Scream (Despair)*, (Plate 24).

The motifs were drawn from his personal memories, some developed from earlier paintings. Thus *The Voice* is an extension of *Puberty* (Plate 8), while we have seen the genesis of *Melancholy* in *Evening*, although the basic theme of a lonely figure on the shore reaches back to *Summer Night (Inger on the Shore)* (Plate 10), and beyond. Munch was haunted by the thought that love and death were mutually dependent, and his *Madonna*'s ecstatic smile as she reaches fulfilment has something corpse-like in it. In the lithographic version (Plate 23), he amplifies this thought by surrounding the figure with a framing design of sperm, while a skeleton-like embryo crouches in the corner. In *The Scream* Munch totally communicates his own schizoid fears, and he re-creates a sunset which to him became coagulated blood, as he 'felt a loud, unending scream piercing nature'. In this apocalyptic scene, where the swirling lines become acoustic reverberations of the scream, he has made a unique visual image of panic.

Fig. 6
Nora
1894. Canvas, 100 x 75 cm.
Private collection,
Switzerland

A few people in Germany could appreciate this kind of painting. Böcklin (Fig. 5) and Klinger had already established an art of inward-looking Symbolism, albeit in a realistic idiom. Indeed Klinger had produced his own pessimistic series of etchings entitled *A Love* in 1887. In 1894 the first book on Munch appeared, containing essays by members of the Scandinavian-slanted intellectual Bohemian circle in Berlin, which congregated at the Black Pig tavern. At its centre were August Strindberg, the Polish writer Stanislaw Przybyszewski, and the German poet Richard Dehmel. The attractive Norwegian *femme fatale* Dagny Juell, who married Przybyszewski and features in Munch's paintings, acted as their exotic muse. From within this circle Julius Meier-Graefe started the important periodical *Pan*. Munch was their leading artist; the Finn, Akseli Gallen-Kallela (who shared an exhibition with Munch), and the Norwegian sculptor, Gustav Vigeland, were also associates. Strindberg, Przybyszewski, and Munch shared many ideas on the psychology of man, the destructive powers of woman, and the superhuman forces, and the artist was clearly at home in this brilliant but over-heated milieu.

Munch's *Life Frieze* subjects, whether inspired by earlier memories or by events in Berlin, typified attitudes held in the Black Pig circle. His powerful idiom of the 1890s, with its swirling lines and bold areas of sonorous colours, expressed uniquely his subjective dramas. *Death in the Sick-Room* (Plate 16) depicts, in the simplified, concentrated new style, the impact of death in his own family. In *The Storm* (Plate 17), turbulence of the elements and of the brush-strokes symbolize the fears of the white-clad figure and the group, from which she is typically isolated. In the painting *Jealousy*, dating from 1894-5 (Plate 26), he uses a new motif to make more explicit the emotion portrayed earlier, in the *Love* series.

In Berlin, Munch also turned to graphic art, thus gaining opportunities for realizing his themes in new forms. Printmaking would allow him to give his artistic ideas wide circulation, and still to retain copies. His first dated engravings are from 1894, and for some time he was to keep to black and white. He worked first with etching or dry-point, which show his delicate line drawing to great advantage, and then proceeded to combine these techniques with aquatint to achieve subtle tonal values. With these his style remained realistic or impressionistic, as with the earlier paintings. Lithographs soon followed, and here Munch became more adventurous (Fig. 7). Lithography invited broad handling, with strong contrasts between sweeping lines and heavy black washes, and it was suitable for large-scale work. Thus he found a graphic medium able to parallel the increasingly simplified designs of his paintings of the middle and later 1890s. During 1895 his prints were exhibited for the first time in Berlin, and also offered for sale in Paris.

Although living in Germany, Munch had continued to spend some time in Norway, and in October 1895 he staged another exhibition in Oslo. But apart from his few supporters (and apparently an interest shown by the elderly Ibsen (Fig. 8), always Munch's favourite playwright), opinion remained hostile there. Critics found the *Love* series 'visions of a sick brain'. The naturalistic painter Erik Werenskiold (a previous supporter), while admiring the relatively realistic *Self-portrait with a Cigarette* (Plate 1), wrote damningly: 'One can trace no development in his work during the last ten years … Now everything is German philosophy, vampires, women sucking men's blood, love and death etc. And that sort of philosophy does not impress me.' Thadée Natanson, editor of the French periodical *La Revue Blanche*, was also in Oslo and reviewed the exhibition. While feeling that Munch

Fig. 7
Self-portrait with
Skeleton Arm
1895. Lithograph,
45.6 x 31.5 cm. Sch.31.
Albertina, Vienna

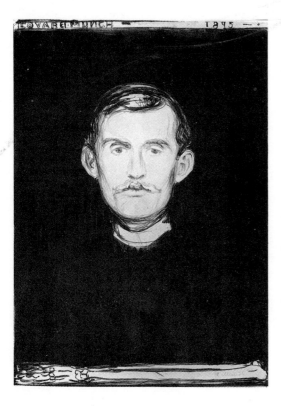

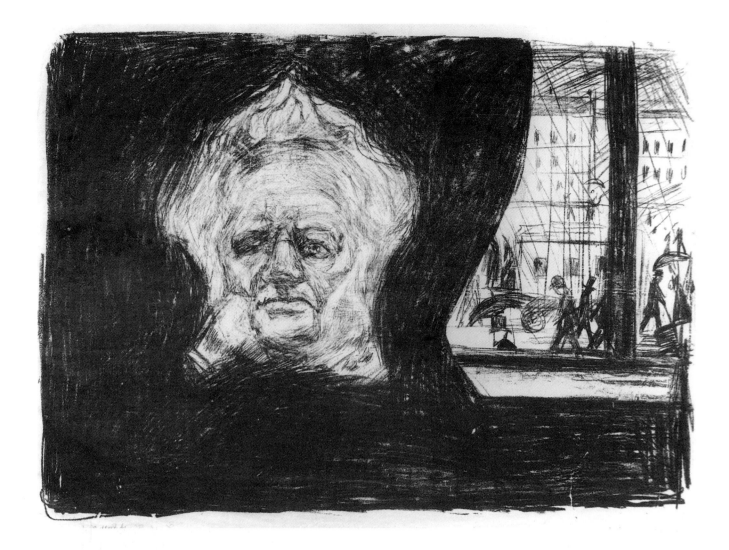

Fig. 8
Ibsen in the Grand
Café
1902. Lithograph,
42 x 58 cm. Sch.171

showed rather too many 'metaphysical speculations', like German art, he showed an interest, recommending that the artist should come to Paris, and reproducing the lithograph *The Scream* in his magazine. The artist had re-visited Paris earlier that year and now resolved on a longer stay.

Munch arrived there early in 1896, to stay nearly a year and a half. Here he became part of a milieu not unlike the Berlin one, indeed several of those members had now moved to Paris. It included Gauguin's friends William Molard and his Swedish sculptor wife Ida Erikson, the composer Delius, and Strindberg, as well as some old Norwegian friends, and he made new contacts in the Symbolist world. Paris, like Germany, was experiencing a phase of interest in Scandinavia, and Munch's commissions included programme designs for Lugné-Pöe's Ibsen productions at the *Théâtre de l'Oeuvre*. He made a portrait of Mallarmé (Fig. 26), and designed illustrations for Baudelaire's *Les Fleurs du Mal*.

But the period's greatest importance was in Munch's development as a printmaker. He was able to collaborate with the most inventive graphic technicians of the day, Clot and Lemercier. He saw Japanese woodcuts, and prints by outstanding modern artists like Bonnard, Gauguin, Toulouse-Lautrec, and Vallotton. Munch now began to print in colour, a field where for originality and beauty he has remained unsurpassed. In 1896 he made his famous lithograph *The Sick Child* (Plate 7), printed in different beautiful colour combinations by Auguste Clot. Here the delicate drawing keeps close to the painting of

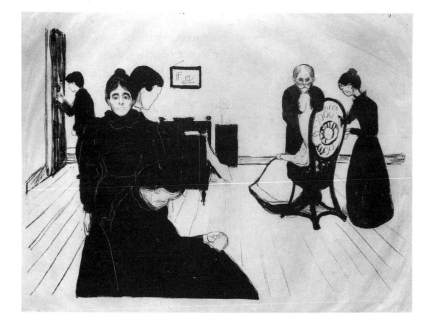

Fig. 9
The Death-Chamber
1896. Lithograph,
39.0 x 55.5 cm. Sch.73.
Municipal Collections,
Oslo

Fig. 10
Funeral March
1897. Lithograph,
55.5 x 37 cm. Sch. 94

ten years before, but usually his colour lithographs are closer to his newer paintings. Sometimes his colour experiments with a print spread over many years. Both *Madonna* (Plate 23) and *Vampire* (Plate 18) started as single-colour lithographs in 1895, and only received their final colour in 1902. In the latter case the artist achieved a particularly rich texture by combining lithograph with woodcut.

Munch's woodcuts are the most individual of all his prints. The first of these, *Fear* (Plate 25), made in 1896, derived through a painting and a colour lithograph, combines motifs from *The Scream* (Plate 24) and *Evening on Karl Johan Street* (Plate 13). The mood of foreboding in the white faces is also apparent in *Moonlight* (Plate 28), but the artist now used colour more subtly. Here Munch employed what was to become a favourite device, sawing the block into several pieces to be inked separately, then re-assembled and printed together. He thus produced a multi-coloured print with an even grain. He also does this in *Melancholy* (Plate 29), developed from the painting *Evening*, of 1891. Because of this ceaseless experimenting, Munch's coloured print subjects frequently occur in many variations of colour and texture.

While in Paris, Munch also exhibited his works, twice at the Salon des Indépendants, where he showed a selection from *The Life Frieze* and once at Bing's gallery, *L'Art Nouveau*, where his friend Meier-Graefe now worked. Strindberg wrote about him in *La Revue Blanche*, and a few critics showed some understanding, notably Edouard Gérard in *La Presse*, who compared his work to Maeterlinck's dramas. Munch must have regarded this stay in Paris as encouraging, and he later expressed gratitude that some appreciation had been shown of the *Life Frieze* pictures.

On leaving Paris, Munch returned home, buying a cottage in Åsgårdstrand. But although he now remained based in Norway for some years, he still travelled vigorously, now including Italy in his visits. Italian Renaissance art probably encouraged his own endeavours towards monumental painting; he admired Michelangelo, in particular the Sistine Chapel. One reason for this restless travelling was his wish to escape from a wealthy young woman who was as determined to marry Munch as he was to remain single. She pursued him remorselessly, threatening his stability and thus further encouraging his heavy dependence on alcohol. For a time he entered a sanatorium, but on his emergence the pursuit continued. The affair ended in a fake suicide

16

attempt at Åsgårdstrand, and an accidental pistol shot which robbed Munch of part of a finger, a wound he never forgot.

Despite these interruptions, the artist continued to find new *Life Frieze* type subjects. *Mother and Daughter* (Plate 27) shows the isolation of youth from age. *Melancholy (Laura)* (Plate 30), based on his unhappy sister, depicts the most extreme form of isolation – that of losing one's reason. The woman sits gazing at nothing, trapped in her corner by the threatening patterns of the blood-red tablecloth. In *The Dance of Life* (Plate 32 and Fig. 26) he develops a favourite theme, his three archetypes of woman. The virgin reaches out towards life, the sensual, red-clothed woman lives it with her partner, while fulfilment has eluded the faded woman on the right. But during the mid-1890s he had also started to set down themes hinting at the more extrovert philosophy which was to be the basis for the Oslo University murals. Around the turn of the century he introduced more objectively-seen motifs and a less pessimistic viewpoint in a number of works. *Girls on the Jetty* (Plate 34) conveys the peaceful atmosphere of a summer evening, and *The Dance on the Shore* (Plate 33), while including the three female types of *The Dance of Life*, has become a midsummer idyll rather than a symbolic statement. Munch now turned again to pure landscapes, producing such atmospheric evocations of the Norwegian scenery as *Winter*, and *White Night* (Plate 35 and Fig. 11). In prints he continued to develop coloured versions of earlier subjects, and also to introduce new themes; the woodcuts were still particularly notable.

In Norway, Munch's main work was still far from acceptance, and although between 1897 and 1901 the National Gallery purchased five paintings, they were all uncontroversial ones. But his real breakthrough came in Germany in 1902. He was invited to make a major contribution to an exhibition of the Berlin Secession, where some of his old friends were now influential. Here he assembled twenty-two of his *Life Frieze*

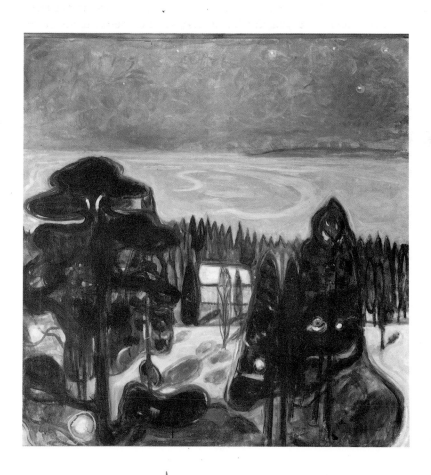

Fig. 11
White Night
1901. Canvas,
110 x 115 cm.
Nasjonalgalleriet, Oslo

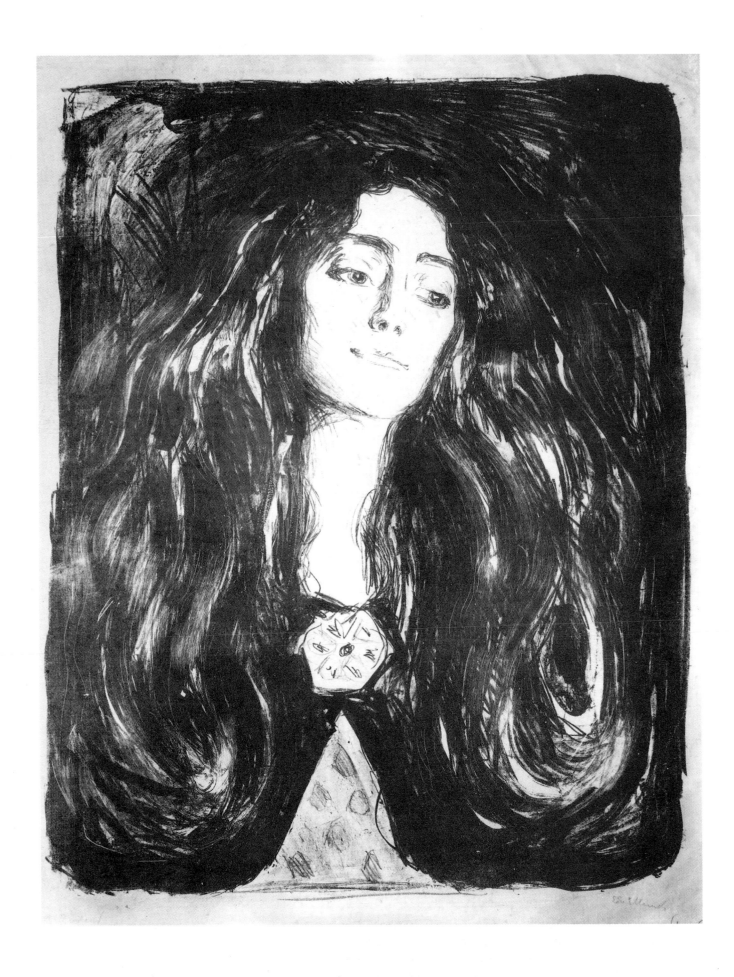

paintings, and they were recognized as original and important. Now success came quickly. Important exhibitions followed in Vienna and Prague, contracts were concluded in Germany with the dealers Bruno Cassirer and Commeter, and within a few years Munch became a major international name east of the Rhine. His work started to influence younger artists in Germany, particularly the Expressionists of *Die Brücke*, and Czechoslovakia. This recognition contrasted with his feelings about Norway. The brutal conclusion of the 'finger affair' caused a break with a number of friends who had been involved. The feeling that Norwegians were persecuting him intensified his insecurity and drinking, and he responded with virulent caricatures and became involved in several brawls. Consequently until 1908 he lived increasingly in Germany and even considered settling there permanently. In Germany, he attracted new patrons, who became firm friends, buying his work and trying to help him manage his life. Such were Dr Max Linde, the Lübeck art connoisseur, the mysterious and wealthy Albert Kollman, the Chemnitz industrialist Herbert Esche, and Gustav Schiefler, the cataloguer of Munch's prints. There was also Count Harry Kessler and the Nietzsche circle in Weimar, and Max Reinhardt, who commissioned stage designs for Ibsen's *Ghosts* and a decorative frieze for his Berlin theatre. Yet difficulties in maintaining the uneasy equilibrium of his life remained, and he wrote to Jens Thiis, one of the most constant Norwegian supporters: 'My fame is increasing, but happiness is another thing'.

After 1900, Munch turned increasingly to nature for new motifs, and this was encouraged by his commissions. He discovered new interest in painting children, which he did very successfully, as in the sophisticated group portrait of Dr Linde's sons (Plate 36). Dr Linde also commissioned a frieze of paintings for the children's room in his home, but despite Munch's attempts to keep the motifs happy and uncomplicated, the doctor did not consider the results suitable, compensating the artist with an alternative purchase. Munch's portraits of adults during this period are also strong, as is the one of Walter Rathenau, his earliest German patron (Plate 37).

In these new subjects, Munch gradually adopted a more brilliant range of colours, and moved from the flat patterns and swirling lines of the 1890s towards a freer, more broken surface. He wrote: 'I had the urge to break areas and lines ... I felt that this way of painting might become a manner ... Afterwards I painted a series of pictures with pronounced, broad lines or stripes, often a metre in length, running vertically, horizontally or diagonally'. It is as if Munch had decided to extend some of the pointillist tendencies of his paintings of 1891, but using stripes instead of irregular dots, and adopting more rectilinear forms. The idea of stripes may have been suggested by the gouged striations of his woodcuts. These experiments were most radical for the few years from 1907 on; and they dominate the *Death of Marat* (Plate 38), a summing up of his feelings on the murderous possessiveness of woman, engendered by the affair of 1902. In the same year he started his heroic *Men Bathing* (Plate 39), the centrepiece of a triptych describing the three ages of man. Progressing from studies of bathing boys from the 1890s, it forms an assertive male complement to his three stages of woman.

Munch's 'nerve-crisis' finally ended in a severe breakdown in 1908, in Copenhagen, and until May 1909 he underwent treatment there at Dr Daniel Jacobson's clinic. He saw the breakdown as the conclusion of a period in his life, and he committed all his will-power to recovering: 'It was in quite a brutal way that I finally made the decision to restore myself ... let us hope that this is the beginning of a new era of my art'.

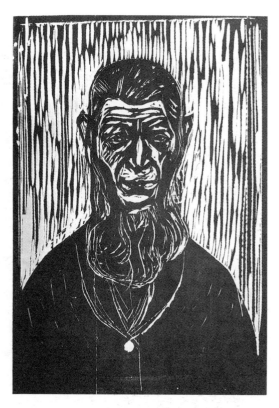

Fig. 13
The Primitive Man
1905. Woodcut,
68.5 x 45.8 cm.
Albertina, Vienna

Fig. 12
Madonna (Lady with
the Brooch)
1903. Lithograph,
60 x 46 cm.
Albertina, Vienna

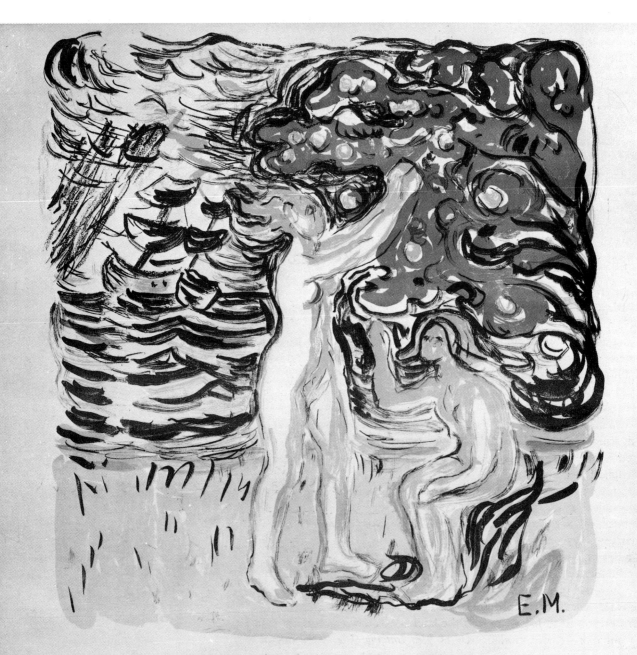

DEN NORSKE KUNST-
≈UDSTILLING≈
CHARLOTTENBORG
NOV.—DEC.

He wrote ironically to a friend: 'I've joined the Order "Don't Indulge" – cigars without nicotine – drinks without alcohol – women without sex' (he was to remain an almost total abstainer from alcohol). While under treatment, Munch continued to work. He drew animals in the zoo and, following his doctor's advice, externalized his fears of woman in the series of lithographs *Alpha and Omega*. This bitter tragi-comedy constituted his last new statement on the theme. He produced several fine portraits, including that of Dr Jacobson, and one of himself, in his experimental style (Plate 2). If the 1895 *Self-portrait with a Cigarette* (Plate 1 and Fig. 16) showed a fear-haunted visionary, this one reveals a fighter who has won his battles and looks ahead with determination.

While he was in Copenhagen, events in Norway were moving in his favour. In 1908 Jens Thiis became director of the National Gallery, purchasing five major works, and Munch was made a knight of the Royal Norwegian Order of St. Olav. Early the following year Thiis and Jappe Nilssen arranged a large exhibition of his paintings and prints, which was a public success. It now became possible for such friends to reassure Munch that he should return to Norway, and this he did on his recovery. Back at home, the artist settled in the small south-coast town of Kragerø, and although he acquired additional properties to give himself more working space, this remained a base for six relatively harmonious years. Here he started to work on designs for the competition for the Oslo University murals.

The University murals provided the long-sought opportunity to create a monumental series of paintings for a permanent setting. The small scale Linde and Reinhardt friezes must have whetted Munch's appetite, but the University project demanded a much more ambitious and majestic solution. Munch wished to create a comprehensible modern classic, both Norwegian and universal, suitable for the new neo-classical hall in Norway's senior academic institution. The theme he chose, of mankind as a harmonious part of nature, was a logical outcome of his search for a new harmony; a complement to the *Life Frieze*. In his own words: 'In respect of their content of ideas the two must be looked upon as a single whole: the *Frieze of Life* presents the sufferings and joys of the individual as seen from close at hand – the University murals show the great eternal forces'. Some of the ideas were developments from motifs of the later 1890s, while others carried on from more recent works, such as *Men Bathing* (Plate 39). Some themes were explored first in new individual pictures, as with *Life* (Plate 40).

The general background of the murals is the southern coast of Norway. Three large paintings each dominate a wall: *The Sun* (Plate 41), *History* (Fig. 15), where an old man instructs a small boy, and *Alma Mater*, symbolizing both motherhood and the University. In between, linking them, are related smaller paintings illustrating mankind's activities and researches in nature, their subsidiary role emphasized by lighter treatment. The most remarkable conception is the centrepiece, *The Sun*. Originally Munch had considered the Nietzschean idea of a mountain of men, struggling towards the sun's light (Fig. 29), but the idea was disliked by the selecting authorities. His final solution, therefore, became the sun itself, bursting up over the coast at Kragerø, its iridescent rays giving energy to the nude figures on the adjoining panels and establishing the keynote for the whole hall.

It is a period when many Nordic artists, for example J.F. Willumsen and Gustav Vigeland, aspired to monumental projects on similar themes of life forces. Among these, Munch's University murals are outstanding, even if, with the exception of *The Sun*, the demands of a public art led him to more conventional solutions than in his most

Fig. 14
Norwegian Art
Exhibition
1915. Colour lithograph,
54.3 x 49.0 cm.
Munch-Museet, Oslo

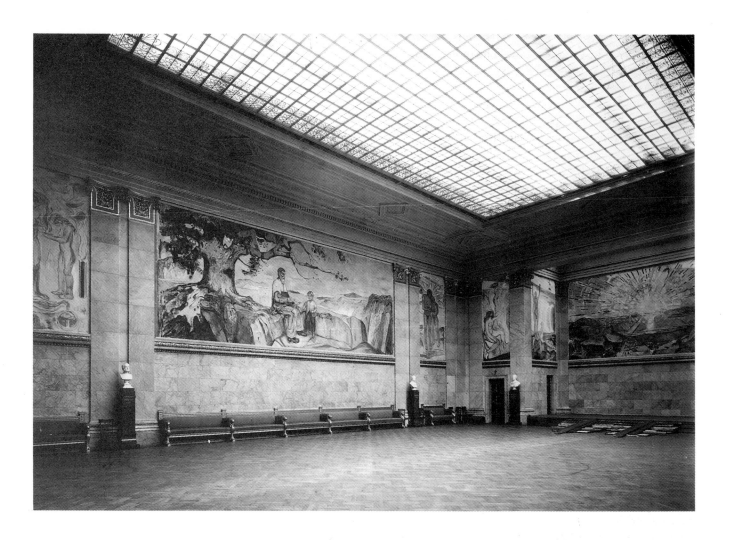

Fig. 15
History
View of the interior of the
Aula of Oslo University,
with panels by Munch
1910-16

imaginative work. Nevertheless it took two competitions, and several years of wrangling, before the pressure of Munch's supporters and weight of his European reputation persuaded the University to accept them. With their unveiling in 1916 the artist had finally won his position in Norway.

The ten years after Munch's homecoming were also exceptionally rich in other works. His technical experiments had now crystallized into rhythmically strong, fluent painting, in brilliant colours. He also introduced this new colour range in his woodcuts with bold ingenuity, as in *Sunbathing (Woman on the Rocks)* (Plate 42), a theme related to the University murals. His thoughts on a public art were now fully aroused: 'Perhaps art once again will become the property of everyone as it was in the olden days – it will appear in public buildings and even on the streets'. Probably Munch's aspirations in this direction encouraged the frequent choice of large format, and possibly also his concentration on extrovert subjects, although in his new life he was also careful not to dwell too much on dangerous past obsessions. He now explored the theme of working life, a territory which he had only occasionally touched on previously. In these new motifs he emphasizes both the dignity and strength of labour, usually presenting the figures frontally, moving towards the viewer, as in *Workmen in the Snow* (Plate 43). In the light-filled *Man in a Cabbage Field* (Plate 44), the labourer's arms sweep up both cabbages and the perspectives of the field into a monumental triangle, as he moves purposefully towards us. With *Horse-team* (Plate 45), the dynamic power is given to the magnificent horses, rather than to the diminutive ploughman who follows them.

In 1916 Munch moved to Ekely, just outside Oslo, which became his final home. He had declared that: 'The only real danger for me is to be unable to work', and Ekely was devoted to avoiding this danger. Almost every room was a working room while outside were open-air studios, and he eventually added a separate large winter studio. Munch increasingly came to regard his paintings as a family, which he needed to have around him. He now hardly ever sold paintings, and he made new versions of ones he no longer possessed, especially if he regarded the themes as belonging to a series. He hoarded old notes and letters, and even toyed with the idea of writing an autobiography. At the same time in the outside world his fame and exhibitions continued to increase. In the 1920s he still made trips abroad, visiting old friends and exhibitions, but from the end of that decade he became increasingly a recluse.

During the 1920s Munch remained prolific. In 1922 he painted appropriately light-weight and charming murals for the canteen of the 'Freia Chocolate Factory in Oslo, and in 1928 he was asked to suggest decorations for the new Oslo Town Hall, then being planned. He set out some ideas incorporating scenes of working men, with *Workmen in the Snow* (Plate 43) as a centrepiece, but the project hung fire, and by the time building commenced ten years later he was really too old for so major a task. With individual paintings there were many re-workings of old themes, and some new subjects based on past memories. But there were also entirely new motifs, magnificent landscapes like *Starry Night* (Plate 46 and Fig. 31) (usually associated with Ibsen's play *John Gabriel Borkman*), or paintings where he could still respond to the beauty of light and colour on a woman's body, as in *Nude by the Wicker Chair* (Plate 47). Ibsen's plays were also important for his print subjects. He added new lithographs to earlier motifs drawn from *Ghosts*, and made a series of woodcuts based on *The Pretenders* (Fig. 32). A model whom he used in connection with that series also inspired the woodcut *Gothic Maiden* (Birgitte Prestøe) (Plate 48), a beautiful blend of expressive drawing and abstract texture.

Eye trouble placed some restrictions on Munch during the 1930s, and his work shows more uneven quality. But his mastery could still assert itself, as in several remarkable self-portraits painted in the last years of his life. In *Self-portrait. Between the Clock and the Bed* (Plate 3), he sees himself with composed irony, the pathos of the 'lean and slippered pantaloon' of old age contrasted with the cheerful colours and the nude study above the bed.

Munch had always been grateful to Germany, but rupture occurred in 1937 when the Nazis declared his art to be degenerate, and removed his paintings from German museums. When Norway was occupied in 1940, he was naturally apprehensive. However, although he refused to have any contact with either German invaders or Norwegian Quislings, Munch remained unmolested, and died peacefully at his home in January 1944. He had just completed a new version of the lithograph portrait of his old friend Hans Jaeger, long since dead. It seems fitting that the artist's last work should recall him. No one of the Oslo Bohemians of the 1880s had more thoroughly fulfilled Jaeger's first principle: 'You must write about your own experiences'.

Outline Biography

1863 12 December: Edvard Munch born in Løten, Norway, son of a military doctor. He has three sisters and one brother. Family moves to Oslo (then Christiania) the following year.

1868 Mother's death from tuberculosis.

1877 Sister Sophie dies of tuberculosis aged fifteen.

1880 Abandons engineering, decides to be a painter.

1881-6 Studies art at the School of Design, Oslo. Influenced by Christian Krohg and Fritz Thaulow.

1883 Shows at the Oslo Autumn Exhibition and regularly thereafter.

1884 Meets the artistic and literary Bohemia in Oslo, notably the anarchist writer Hans Jaeger.

1885 Three week stay in Paris. Begins *The Sick Child* back in Oslo.

1886 *The Sick Child* shocks the public at the Oslo Autumn Salon.

1889 First one-man exhibition, Oslo. State scholarship to Paris, renewed on two further occasions. Attends Léon Bonnat's art school. November: father dies. *St. Cloud Manifesto* ends his 'Naturalist' period. Summer in Åsgårdstrand as in following years.

1890-2 Frequent travels to Le Havre, Nice, Paris and subsequently Berlin.

1891 Begins *The Frieze of Life* cycle of paintings.

1892 Berlin exhibition is *succès de scandale*; closed after one week due to public protest. Fame in Germany ensured.

1892-5 Lives mainly in Berlin with visits to Paris.

1893 Paints *The Scream*. Contact with Strindberg, Meier-Graefe, Przybyszewski and The Black Piglet café literary circle.

1894 First etchings and lithographs. Paints *Madonna*.

1895 Visits Paris twice; Toulouse-Lautrec, Bonnard and Vuillard are influences. Brother Andreas dies.

1896 Spring in Paris. Illustrates programme for Ibsen's *Peer Gynt*. Exhibits at Salon des Indépendents. Meets Mallarmé.

1897 Paris again – programme design for Ibsen's *John Gabriel Borkmann* (Ibsen), but summer in Norway; successful Oslo exhibition.

1898-1901 Many travels to Germany, France, Italy.

1900 Completes *The Dance of Life*. Stays in a Swiss sanatorium.

1902 Berlin Secession exhibits *The Frieze of Life*, an important breakthrough. Contact with Dr Max Linde. First photographic studies. Ending an unhappy love affair results in gunshot wound from ex-lover.

1905 Major exhibition in Prague. Nervous strain and drinking problems increase; takes health cures in Germany. Quarrels with Norwegian friends.

1906-8	Lives mainly in Germany; working for the Max Reinhardt in Berlin (oval hall in Chamber Theatre) and the Nietzsche circle in Weimar.	1926	Travels in Germany and Switzerland. Sister Laura dies.
		1927	Remains in Norway but major shows in Berlin and Oslo National Galleries.
1908	Exhibits with Die Bruecke in Dresden. October: nervous break-down in Copenhagen; six months in a clinic follow. State honour from Norway.	1928	Oslo Town Hall murals designed.
		1930	Eye trouble interrupts work.
1909	Lives in Norway. Starts work on Oslo University Great Hall murals.	1933	Seventieth birthday tributes include monographs by Jens This and Pola Gauguin.
1912	Exhibited at Cologne Sonderbund, along with Van Gogh, Gauguin and Cézanne.	1936	First English exhibition. More eye trouble halts work on town hall murals.
1913	Many travels to Berlin, Frankfurt, Cologne, Paris, London, Stockholm, Hamburg, Luebeck, Copenhagen. Fiftieth birthday tributes. Represented in Armory Show, New York City.	1937	Eighty-two of his works in Germany labelled 'degenerate' by Nazis; they are later sold in Norway.
		1940	April: Germany invades Norway. Munch refuses contact with either occupation forces or native collaborators.
1914	University murals finally accepted.		
1916	Makes his home at Ekely, near Oslo.		
		1943	Eightieth birthday tributes.
1918	*The Frieze of Life* pamphlet published.	1944	23 January: dies peacefully at Ekeley. Bequeaths all his work to Oslo: 1,008 paintings, 15,391 prints, 4,443 drawings, six sculptures.
1920-1	Travels to France and Germany.		
1922	Mural decorations for Freia chocolate factory, Oslo. Major show in Zurich. Supports German artists by buying graphic works.		

Select Bibliography

CATALOGUES

Carla Lathe, *Edvard Munch and His Literary Associates*, UEA, Norwich, England, 1979.

H.B. Muller, *Edvard Munch. A Bibliography. Oslo Kommunes Kunstsamlinger Arbok 1946-1951*, Oslo, 1951. Supplement in *Oslo Kommunes Kunstsamlinger Arbok 1952-9'*, Oslo, 1960.

Munch–Museet, *Catalogue 4, 1967*, Oslo, 1967.

Edvard Munch: Symbols & Images National Gallery of Art, Washington DC, 1978-9.

MONOGRAPHS

Otto Benesch, *Edvard Munch*, translated by Joan Spencer. London, 1960.

Ulrich Bischoff, *Edvard Munch*, Cologne, 1986.

Ingrid Langaard, *Edvard Munch. Modningsar*, Oslo, 1960.

Johann H. Langaard, *Edvard Munch*, translated by Michael Bullock. New York-Toronto, 1964.

Werner Timm, *The Graphic Art of Edvard Munch*, translated by Ruth Michaelis-Jena with the collaboration of Patrick Murray. New York, 1969.

Reinhold Heller, *Munch: The Scream*, London, 1973.

___, *Munch: His Life and Work*, London, 1984.

J.P. Hodin, *Edvard Munch*, London, 1972.

Thomas M. Messer, *Edvard Munch*, New York, 1973. Concise edition, London, 1987.

Nic Stang, *Edvard Munch*, Oslo, 1972.

Rolf Stenersen, *Edvard Munch: Close-up of a Genius*, Oslo, 1969.

Jens Thiis, *Edvard Munch og hans samtid*, Oslo, 1933.

B. Torjusen, *Words and Images of Edvard Munch*, London, 1989.

List of Illustrations

Colour Plates

1. Self-portrait with a Cigarette
 1895. Canvas, 110.5 x 85.5 cm.
 Nasjonalgalleriet, Oslo

2. Self-portrait
 1909. Canvas, 100 x 110 cm.
 Rasmus Meyers Samlinger, Bergen

3. Self-portrait: Between the Clock
 and the Bed
 1940-2. Canvas, 149 x 120.5 cm.
 Munch-Museet, Oslo

4. From Maridalen
 1881. Oil on cardboard, 20 x 30 cm.
 Nasjonalgalleriet, Oslo

5. Girl on the Edge of the Bed
 1884. Canvas, 96.5 x 103.5 cm.
 Rasmus Meyers Samlinger, Bergen

6. The Sick Child
 1885-6. Canvas, 119.5 x 118.5 cm.
 Nasjonalgalleriet, Oslo

7. The Sick Child
 1896. Lithograph, 42.1 x 56.5 cm.
 Sch.59. Munch-Museet, Oslo

8. Puberty
 1895. Canvas, 151 x 110 cm.
 Nasjonalgalleriet, Oslo

9. Night in St. Cloud
 1890. Canvas, 64.5 x 54 cm.
 Nasjonalgalleriet, Oslo

10. Summer Night (Inger on the Shore)
 1889. Canvas, 126 x 161.7 cm.
 Rasmus Meyers Samlinger, Bergen

11. Military Band on Karl Johan Street
 1889. Canvas, 102 x 141.5 cm.
 Kunsthaus, Zurich

12. Spring Day on Karl Johan Street
 1891. Canvas, 80 x 100 cm.
 Billedgalleri, Bergen

13. Evening on Karl Johan Street
 1892. Canvas, 84.5 x 121 cm.
 Rasmus Meyers Samlinger, Bergen

14. Portrait of Hans Jaeger
 1889. Canvas, 109.5 x 84 cm.
 Nasjonalgalleriet, Oslo

15. Portrait of the Artist's Sister, Inger
 1892. Canvas, 172 x 122.5 cm.
 Nasjonalgalleriet, Oslo

16. Death in the Sickroom
 c.1893. Casein on canvas, 150 x 167.5 cm.
 Nasjonalgalleriet, Oslo

17. The Storm
 1893. Canvas, 98 x 127 cm.
 Museum of Modern Art, New York

18. Vampire
 1895-1902. Lithograph and woodcut, 38.8 x 55.2 cm.
 Sch.34. Munch-Museet, Oslo

19. The Kiss
 1892. Canvas, 73 x 92 cm.
 Nasjonalgalleriet, Oslo

20. The Voice
 c.1894-5. Canvas, 88 x 100 cm.
 Munch-Museet, Oslo

21. Melancholy
 c.1892-3. Canvas, 64.5 x 96 cm.
 Nasjonalgalleriet, Oslo

22. Madonna
 c.1893. Canvas, 91 x 70.5 cm.
 Nasjonalgalleriet, Oslo

23. Madonna
 1895-1902. Lithograph, 61 x 44.1 cm.
 Sch.33. Munch-Museet, Oslo

24. The Scream
 1893. Oil pastel and casein on cardboard,
 91 x 73.5 cm. Nasjonalgalleriet, Oslo

25. Fear
 1896. Woodcut, 46 x 37.7 cm.
 Sch.62. Munch-Museet, Oslo

26. Jealousy
 1894-5. Canvas, 66.8 x 100 cm.
 Rasmus Meyers Samlinger, Bergen

27. Mother and Daughter
c.1897. Canvas, 135 x 163 cm.
Nasjonalgalleriet, Oslo

28. Moonlight
1896. Woodcut, 41 x 46.9 cm.
Sch.81. Munch-Museet, Oslo

29. Melancholy
1896. Woodcut, 37.6 x 45.5 cm.
Sch.82. Munch-Museet, Oslo

30. Melancholy (Laura)
1899. Canvas, 110 x 126 cm.
Munch-Museet, Oslo

31. Girls on the Bridge
1920. Coloured woodcut and lithograph,
50 x 43.2 cm. Private collection

32. The Dance of Life
1899-1900. Canvas, 125.5 x 190.5 cm.
Nasjonalgalleriet, Oslo

33. The Dance on the Shore
1900-02. Canvas, 95.5 x 98.5 cm.
Narodni Galerie, Prague

34. Girls on the Jetty
c.1899-1901. Canvas, 136 x 125.5 cm.
Nasjonalgalleriet, Oslo

35. White Night
1901. Canvas, 115.5 x 110.5 cm.
Nasjonalgalleriet, Oslo

36. The Four Sons of Dr. Max Linde
1903. Canvas, 144 x 199.5 cm.
Museum Luebeck

37. Portrait of Walter Rathenau
1907. Canvas, 220 x 110 cm .
Rasmus Meyers Samlinger, Bergen

38. Death of Marat
1907. Canvas, 151 x 148 cm.
Munch-Museet, Oslo

39. Men Bathing
1907-8. Canvas, 206 x 227 cm.
Ateneumin Taidemuseo, Helsinki

40. Life
1910. Canvas, 196 x 370 cm. Town Hall, Oslo

41. The Sun (central painting of Oslo
University murals)
1909-16. Canvas, 455 x 780 cm.
University Assembly Hall, Oslo

42. Sunbathing (Woman on the Rocks)
1915. Woodcut, 35.1 x 56.6 cm.
Sch.440. Munch-Museet, Oslo

43. Workmen in the Snow
1912. Canvas, 161 x 195.5 cm.
Munch-Museet, Oslo

44. Man in a Cabbage Field
1916. Canvas, 136 x 181 cm.
Nasjonalgalleriet, Oslo

45. Horse-team
1919. Canvas, 110.5 x 145.5 cm.
Nasjonalgalleriet, Oslo

46. Starry Night
1923-4. Canvas, 120.5 x 100 cm.
Munch-Museet, Oslo

47. Nude by the Wicker Chair
1929. Canvas, 122.5 x 100 cm.
Munch-Museet, Oslo

48. Gothic Maiden (Birgitte Prestoe)
1931. Woodcut, 59.6 x 32.1 cm.
Munch-Museet, Oslo

Text Figures

1. Self-portrait
 1905. Gouache. Nasjonalgalleriet, Oslo

2. Ferdinand Hodler: Lake Thun
 1905. Canvas, 80.2 x 100 cm.
 Geneva Art and History Museum

3. The Day After
 1894-5. Canvas, 115 x 152 cm.
 Nasjonalgalleriet, Oslo

4. Road in Åsgårdstrand
 1902. Canvas, 88 x 114 cm.
 Private collection, Basel

5. Arnold Boecklin: The Island of the Dead
 1880. Canvas. Metropolitan Museum of Art,
 New York

6. Nora
 1894. Canvas, 100 x 75 cm.
 Private collection, Switzerland

7. Self-portrait with Skeleton Arm
 1895. Lithograph, 45.6 x 31.5 cm. Sch.31.
 Albertina, Vienna

8. Ibsen in the Grand Café
 1902. Lithograph, 42 x 58 cm. Sch.171

9. The Death-Chamber
 1896. Lithograph, 39.0 x 55.5 cm. Sch.73.
 Municipal Collections, Oslo

10. Funeral March
 1897. Lithograph, 55.5 x 37 cm.
 Sch.94

11. White Night
 1901. Canvas, 110 x 115 cm.
 Nasjonalgalleriet, Oslo

12. Madonna
 (Lady with the Brooch)
 1903. Lithograph, 60 x 46 cm.
 Albertina, Vienna

13. The Primitive Man
 1905. Woodcut, 68.5 x 45.8 cm.
 Albertina, Vienna

14. Norwegian Art Exhibition
 1915. Colour lithograph, 54.3 x 49.0 cm.
 Munch-Museet, Oslo

15. History
 View of the interior of the Aula of Oslo University,
 with panels by Munch 1910-16

Comparative Figures

16. Self-portrait with a Cigarette
1909. Lithograph, 56 x 46 cm

17. Spring
1889. Canvas, 169 x 264 cm.
Nasjonalgalleriet, Oslo

18. Edouard Manet:
The Roadmenders, Rue de Berne
1878. Canvas, 63 x 79 cm.
Fitzwilliam Museum, Cambridge

19. Death Agony
Lithograph, 39 x 50 cm. Albertina, Vienna

20. Franz von Stuck: Sin
1893. Canvas, 93 x 59 cm.
Neue Pinakothek, Munich

21. The Kiss
1895. Drypoint and aquatint, 34.3 x 27.8 cm.
Albertina, Vienna

22. Moonlight
c.1894-5.

23. Ashes
1894. Canvas, 120 x 141 cm.
Nasjonalgalleriet, Oslo

24. Anxiety
c.1894. Canvas, 93 x 73 cm.
Kunstammlung, Oslo

25. Mallarmé
1896. Lithograph, 40.1 x 28.9 cm.
Municipal collections, Oslo

26. The Three Ages of Woman
1899. Lithograph, 46 x 59.5 cm.
Albertina, Vienna

27. Four Girls at Åsgårdstrand
1902. Canvas, 89.5 x 125.5 cm.
Staatsgalerie, Stuttgart

28. Self-portrait with Wine-Bottle
1906. Canvas, 110.5 x 120.5 cm.
Munch Museet, Oslo

29. The Mountain of Men in the Open-Air
Studio at Ekely

30. Diggers on the Road
c.1912. Lithograph, 43.5 x 61 cm.
Albertina, Vienna

31. Starry Night
c.1893. Canvas, 133 x 139 cm.
Private collection, Oslo

32. The Trial By Fire, illustration for
'The Pretenders' by Ibsen
c.1927-31. Woodcut, 46 x 37 cm.

The Plates

1 Self-portrait with a Cigarette

1895. Canvas, 110.5 x 85.5 cm. Nasjonalgalleriet, Oslo

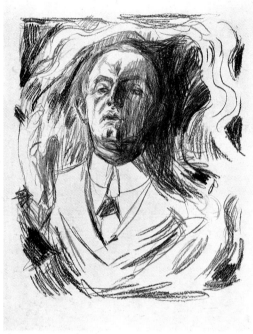

The artist's glaring, underlit features emerge from a briskly-painted but indeterminate monochromatic background, such that only his face, collar and tie, and hand holding the cigarette stand out. At once aggressive and defensive, the ambiguous pose simulates a photographic snap-shot but adds a range of emotional responses in the thin, scraped veils of paint used for the clothing, and the blank but mordant gaze. Painted towards the end of Munch's first German sojourn, the picture reflects knowledge of that country's portrait tradition, from Dürer onwards; both Hodler and Kokoschka were to use similar emphases on the hand and face in their expressionistic portraits of the following decade.

Munch's lithographic self-portrait of the same year is more gloomy, with a solid black background instead of the organic texture of the oil, and his own arm replaced by a skeleton's in the medieval German tradition of *memento mori*. A 1908-9 version, again a lithograph, shows a more worldly, almost arrogant pose (Fig. 16).

'The camera cannot compete with brush and palette – as long as it cannot be used in hell or heaven', Munch declared.

Fig. 16
Self-portrait with Cigarette

1908-9. Lithograph,
56 x 46 cm.

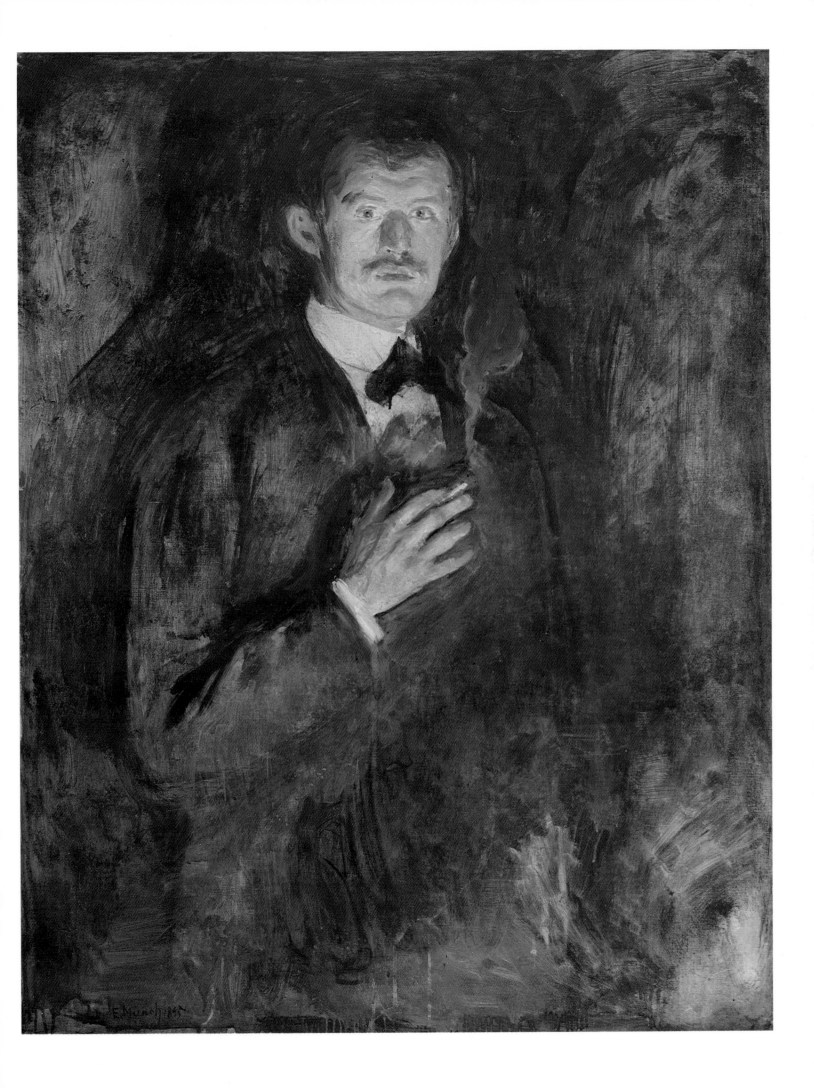

2 Self-portrait

1909. Canvas, 100 x 110 cm. Rasmus Meyers Samlinger, Bergen

Produced in the year following Munch's nervous breakdown, and subsequent cure in a Copenhagen clinic, this work blares vitality almost as a defensive reflex, with the sharp colour contrasts on the wall behind the artist's head, and the very free and vigorous paint application. The patrician gaze is more assured than in the previous work, although a sense of weariness is also detectable. It is as though, like Thomas Mann's Aschenbach in *Death in Venice* (1911), Munch felt he was 'the poet-spokesman for all those who laboured on the edge of exhaustion'. The heightened contrast of the pure blue and red, on the chair arm and on the artist's sleeve, grabs our attention in the manner of the French Fauves (Derain in particular), and the German 'Die Brucke' artists, Kirchner and Schmitt-Rottluff, who acknowledged Munch as a major influence on them through his graphic works of the 1890s. This use of colour may be repayment of a debt of influence, and an attempt by the forty-five-year-old artist to establish his credentials with his younger German contemporaries. Although his mental equilibrium was precarious, there is nevertheless a feeling of splendid isolation in this painting; a sense of having won through. A certain irony pervades Munch's view of his predicament at this time, as is shown by the sketches he made of himself on the disection table in the clinic, with his doctor looking on. This sense of detached commentary is also borne out by the next plate.

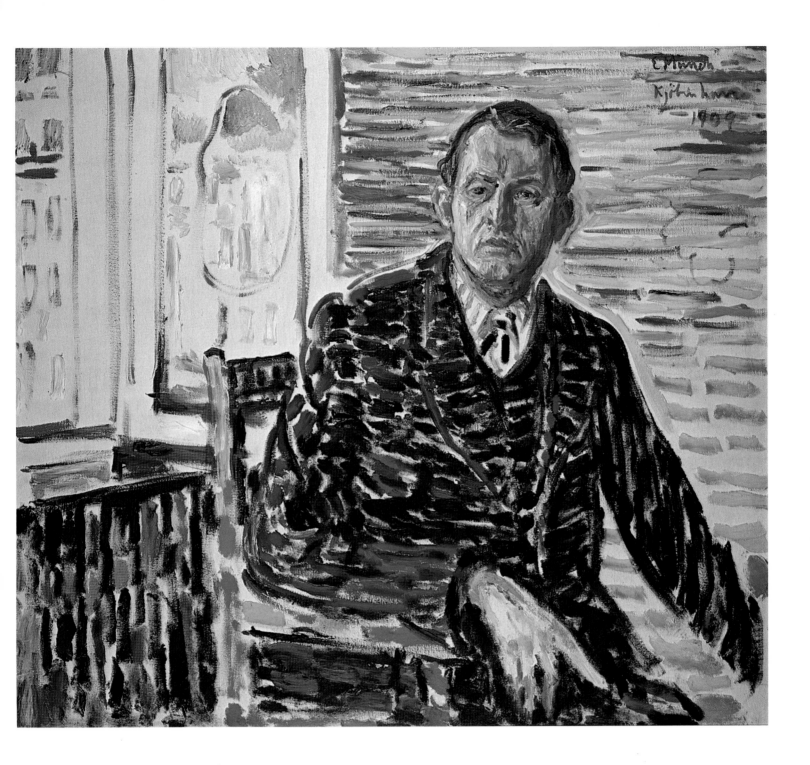

Self-portrait. Between the Clock and the Bed

1940-2. Canvas, 149 x 120.5 cm. Munch-Museet, Oslo

Munch seems to share W.B. Yeats's vision of 'a tattered coat upon a stick' as the final effect of the depradations of age. The painter sees not the strong if somewhat exhausted figure of 1909, but a 'slippered pantaloon', almost as much a 'thing' as the twin poles of his room, the clock and the bed. The ravages of time and the privations of living in an occupied country, while refusing to have any contact with the occupiers, perhaps accounts for the fragile pride still perceptible in the military bearing. It is as though Munch forces himself to stand to attention against Time and Fate (the clock and the bed). Shoulders sag, arms hang limply, in a parody of the clock, whose face echoes his own, and his stiffness is gently mocked by the sinuous female nude in the painting on the far right. His blue and green clothes are set against the radiant orange and yellow of the background, with the result that he seems to shrink still further. The bed-cover, tenuously delineated, is reminiscent of a flag draped over a catafalque. Yet there is no self-pity in the portrait, and the acuity of self-presentation, matched by the swirling brush-strokes and dripping paint, particularly around the bed, suggest that Munch was worried that time might run out before he finished this painting.

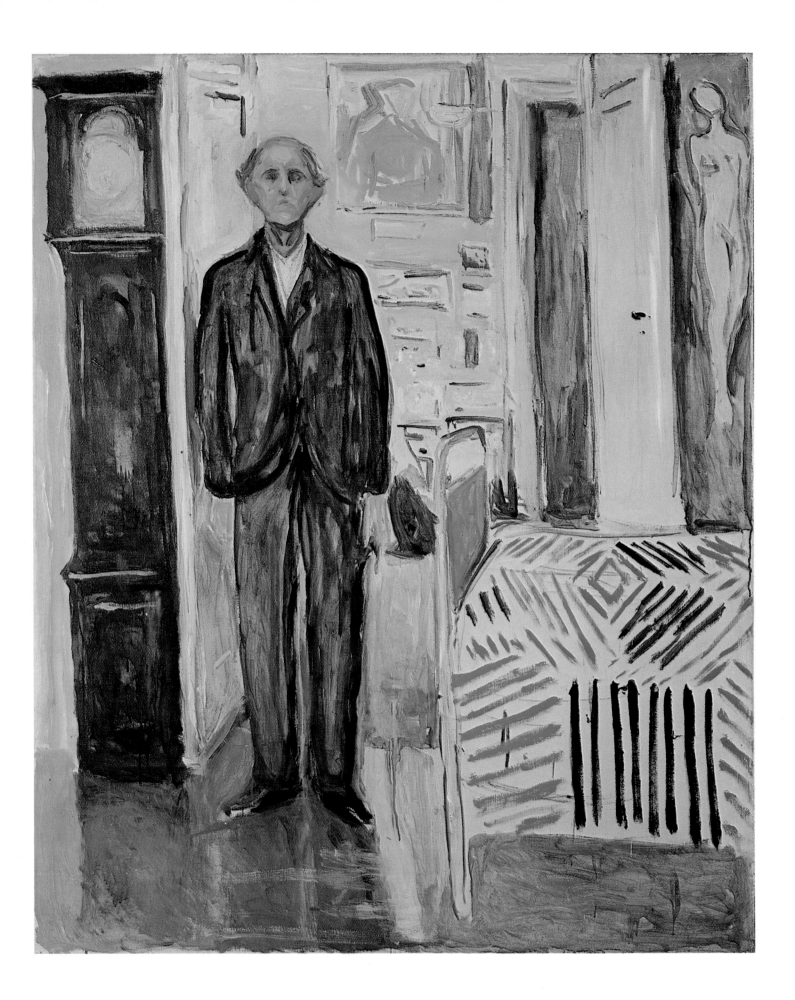

4 From Maridalen

1881. Oil on cardboard, 20 x 30 cm. Nasjonalgalleriet, Oslo

Following his decision in 1880 to abandon engineering and take up paint-
ing, Munch became involved with avant-garde circles in Christiania
through his enrolment at the academy, and more especially via his tutor
Frits Thaulow, an exponent of *plein air* painting reminiscent of the French
Barbizon group and Corot. Equally important was the combative and ener-
getic support of Christian Krohg, the leading painter of the Christiania-
Boheme radicals. Corot's influence is particularly evident in this work,
which shows a strong grasp of formal, structural components. The grey,
silver, silver-blue and flaxen tones are modulated in a flexible, mellow
range, especially along the low wall and in the shadows on the road. Similar
effects can be seen in Corot's *View of Avignon* of the 1820s. Hints of
Munch's future development can be seen in the taut yet distant relation-
ship of the two figures. The pensive figure on the right will, a decade later,
as in *Inger on the Shore* (Plate 10) or *Melancholy* (Plate 21), come to dominate
his landscapes. Munch's predilection for strong dynamics in his landscape
construction is also already apparent in the balance between the railing and
the stark, clearly delineated dwellings, and in the long shadow of the tree
sketching across the road and moving strongly into the picture-plane.

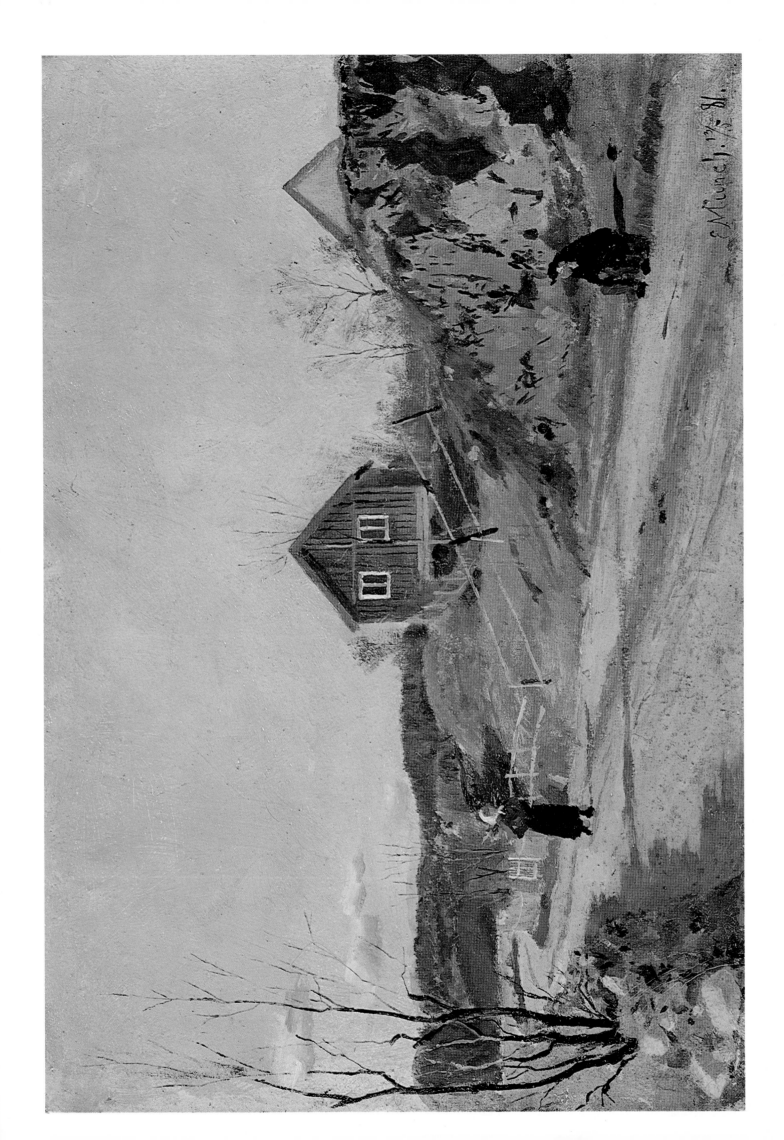

5 Girl on the Edge of the Bed

1884. Canvas, 96.5 x 103.5 cm. Rasmus Meyers Samlinger, Bergen

Munch uses much the same coolly luminous palette here as he did in *From Maridelen* (Plate 4), but in the three years that separate the paintings his ability to create atmosphere and presence has greatly developed. From the solid and emphatic form of the girl, to the evanescent glass on the table at left, Munch's handling of the paint is increasingly deft and sympathetic to the subject. The powerful construction of the horizontal and vertical planes is reinforced by the contrast between the light white and blue background and the dark colour of the girl's skirt. Between this contrast lies the vibrant brown-gold colour of her hair and the carefully weighed light and dark tones of her brooding face. This mood of reverie marks an emotional development beyond the influence of Degas, whose women in domestic settings are engaged in humdrum activity, whereas Munch portrays a more reflective being.

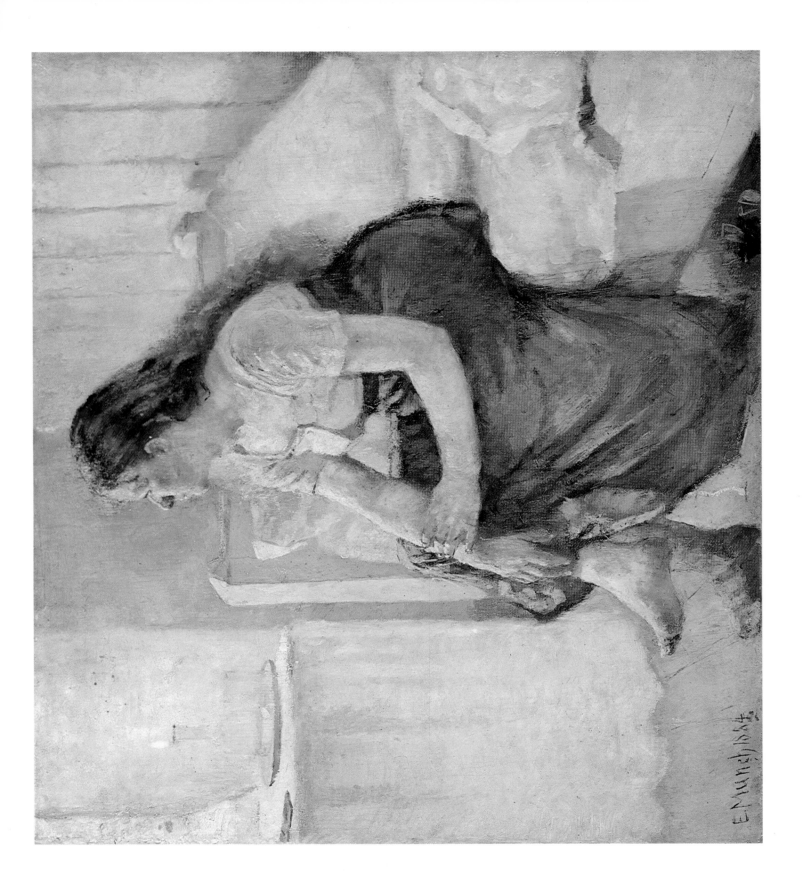

The Sick Child

1885-6. Canvas, 119.5 x 118.5 cm. Nasjonalgalleriet, Oslo

This painting makes overt reference to the sickness-and-death shrouded world of the painter's youth: 'disease and madness and death were the black angels standing by my cradle'. The inspiration for this powerful, compassionate work was the grief of a young girl for a dying relative which Munch witnessed. He transposes the memory of that event and presents the girl herself as the subject, the sick child. In referring to this period in Scandinavian painting as 'the Age of the Pillow', Munch was alluding to numerous paintings by contemporary Norwegian artists (such as Krohg) showing sick-room scenes: tuberculosis was rife in Scandinavia at the end of the nineteenth century. Munch's later painting *Spring* of 1889 (Fig. 17) is again in this Scandinavian tradition. *The Sick Child*, however, differs in its scraped, 'unfinished' handling: 'in the course of a year I scratched it out countless times – I wanted to catch the first impression – but gradually I tired out and the colours became grey', an effect exacerbated by the careless treatment the work received later, being left outdoors to gain a 'patina' as might a sculpture. This 'weathering' poses serious problems for conservators of Munch's work. Nevertheless, this handling does confer an air of poignancy on the scene, in accordance with the symbolist ideals of imprecision, mystery and the ethereal. The light source appears to be the face of the hectic, fevered girl herself. Even more than his contemporaries, Munch suggests the halo-like quality of the pillow, with the medieval intensity of the delicate profile intimating the sacred nature of threatened life. Elsewhere the jagged brushstrokes of the black and sombre curtain on the right suggest the impending doom of the patient.

The critics, as expected, mauled the piece mercilessly when it was shown in Christiania. The lack of 'finish' was considered the chief failing, and the colouring was also judged unfortunate. Yet what could be more appropriate, and realistic, than the lank appearance and acidic tone of her hair? Successive versions of the painting were to amplify this effect – the Tate Gallery's version of 1907 is even more virulent – as Munch tried to emulate the searing juxtapositions of colour of the 'Bruecke' artists which were well-known and admired by this later date. 'In *The Sick Child* I broke new ground – it was a breakthrough in my art – most of what I later have done had its birth in that painting.'

Fig. 17
Spring

1889. Canvas, 169 x 264 cm.
Nasjonalgalleriet, Oslo

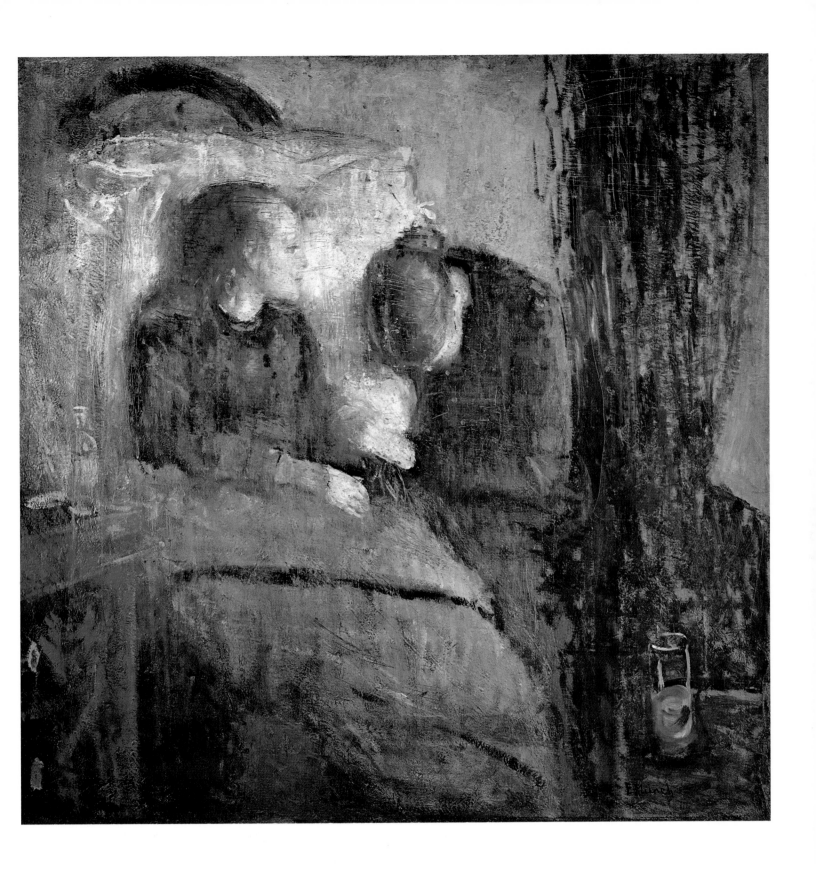

7 The Sick Child

1896. Lithograph, 42.1 x 56.5 cm. Schiefler. No. 59. Munch-Museet, Oslo

Munch had discovered the flexible, expressive qualities of the graphic media while in Germany, and they enabled him to focus on the constructional and monumental elements in the composition which the need for *timbre* in the oil-paintings often prevented. The prints consequently often appear more 'modern' than the original paintings from which they were taken. In this version of *The Sick Child* (Plate 6) the last vestiges of nineteenth-century sentimentality have been excised, although the image of the girl's head is an exact transcription. The scratchy, indecisive ink-marks, as well as the dark band at which the girl stares, give a transient quality to the profile, now strongly irradiated and illuminating. The paring away of the *mise-en-scène* is another attribute of Munch's graphic work when it derives from earlier oil-paintings. This picture is a telling example of Munch's claim in his St Cloud Manifesto that he would 'no longer paint interiors of people reading and women knitting', but rather 'living beings, who breathe and feel, suffer and love'.

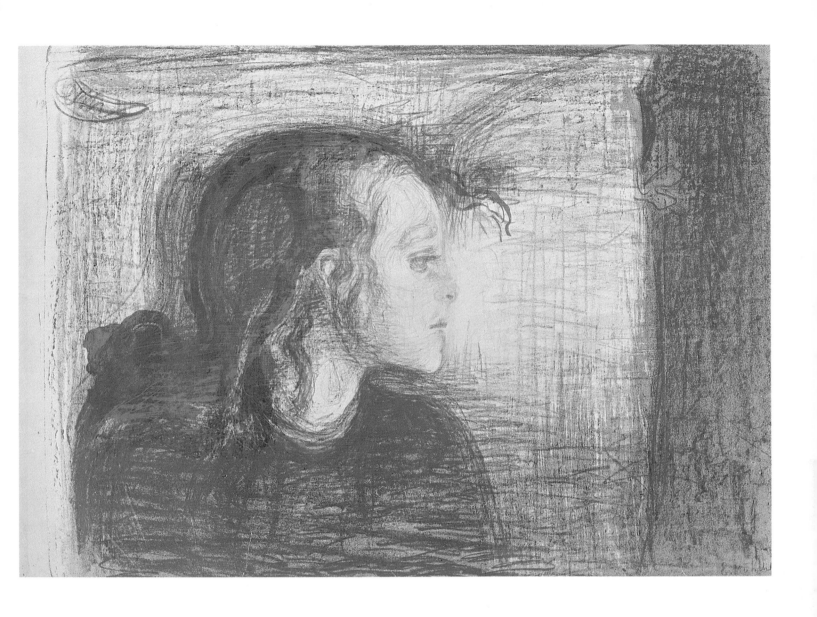

8 Puberty

1895. Canvas, 151 x 110 cm. Nasjonalgalleriet, Oslo

Dating from the same year as the *Self-portrait with a Cigarette* (Plate 1) and just preceding the lithograph of *The Sick Child*, this work is a raw observation of puberty and the often terrifying transition from child to adult experienced by girls in conventional society at this time; something challenged vociferously by the 'Christiania-Boheme'. *Puberty* eschews the symbolic emblems of *Madonna* (Plate 22), and presents a nakedness desperately unsure of itself. Again, a strong horizontal-vertical axis is used to stress the gawky features of the girl, who looks as though she is being crucified by uncertainty. The artist conveys this impression by enlarging her heavy-boned hands at the end of her spindly arms, and by her narrow chest. The vague air of threat and menace, so sought after in the symbolist milieu Munch was to find in Paris, through the writings of Baudelaire and Edgar Allan Poe, is made palpable here by the ballooning shadow that seems to have designs on the girl's vulnerable body. Yet for all these allusions, the work has a certain objectivity; as though something experimental were being studied. It was this intense scrutiny that shocked contemporary Norwegian critics.

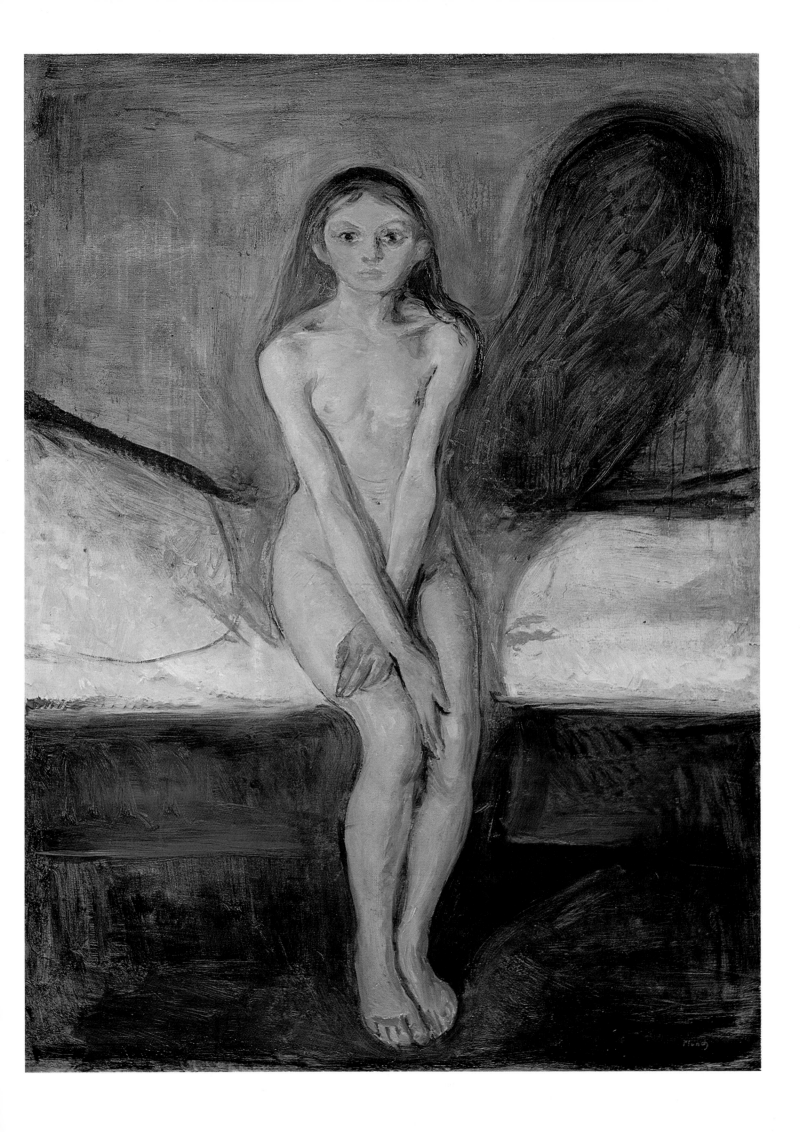

Night In St Cloud

1890. Canvas, 64.5 x 54 cm. Nasjonalgalleriet, Oslo

Through recommendations from his teachers, Munch gained three scholarships to study in Paris from 1889 to 1891. Personal illness, and family tragedies such as the death of his father in the autumn of 1890, failed to prevent Munch absorbing a wealth of information in what was then regarded as the Capital of Art. At this time, 'divisionism', to give *pointillism* its official title, was in vogue although Seurat's death in 1891 deprived the technique of its foremost exponent (Signac and other followers were less punctilious in the 'scientific' application of his discoveries). In this painting, however, the formal innovations of Degas are in the ascendancy; the use of colour is subtle and vibrant but hardly radical; and Scandinavian touches abound, as in the 'still-life' aspect of the lantern, the most focussed object in the room. Although more freely handled, the seascape in the distance has Whistlerian harmonics and highlights, while the ribbon of light across the water is the prototype for the elemental and symbolic solar/lunar reflections in the Norwegian landscapes of Munch's series of paintings which he called *The Frieze of Life*. The silhouette of the figure owes much to Degas, but has an added brooding intensity that may reflect Munch's response to his father's death. The grid-design of the windows will recur as a powerful constructional device (see Plate 19).

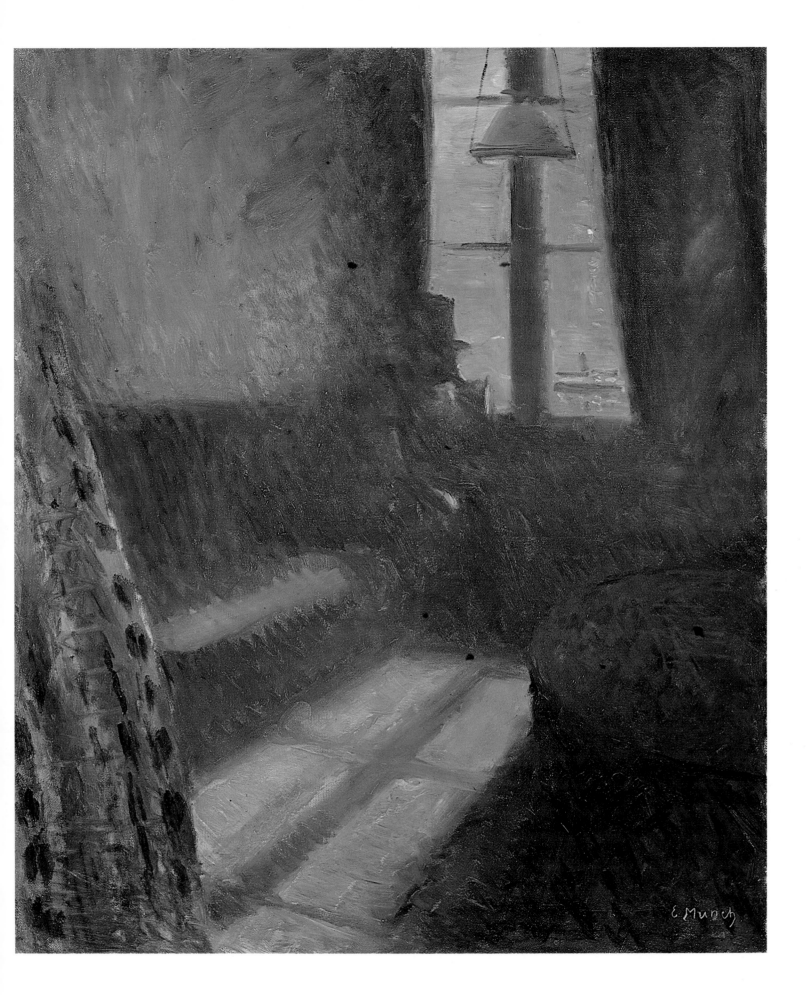

Summer Night (Inger on the Shore)

1889. Oil on canvas, 126 x 161.7 cm. Rasmus Meyers Samlinger, Bergen

Inger's strong, calm presence is depicted in many guises by Munch, whether as the grief-stricken, exhausted nurse in *Death in the Sick Room* (Plate 16), or as a formally-posed portrait model (Plate 15). Here, her identity is obliquely alluded to, and her portrait merges so effectively with the calm surroundings that it marks another successful step in Munch's life-long attempt to integrate humanity with the natural world. The light and colour are still in the same range as *From Maridalen* (Plate 4) of eight years earlier, but the confident, rounded curves and masses of the boulders, complemented by the plainly-falling simple dress of his sister, show that Munch was now thinking in terms of volume and mass, rather than merely effects of surface texture. However, this was not a steady development, as a comparison with both *Night in St Cloud* (Plate 9) and Plate 11 reveals. The pensive mood of the scene will recur, reinforced, in the theme of *The Voice*, in which a feminine figure tunes in, through the mystery of the Nordic mid-summer night, to the essence of her existence.

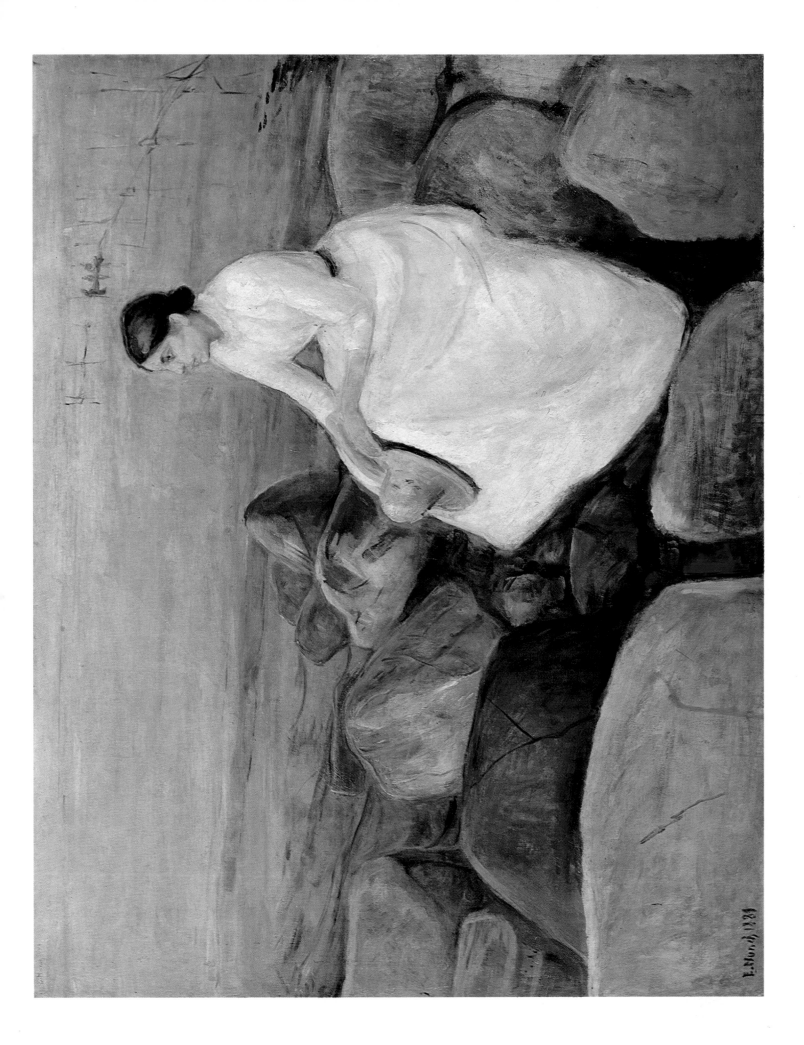

1889. Canvas, 102 x 141.5 cm. Kunsthaus, Zurich

If Plate 9 shows the influences on Munch of Degas and Whistler in the painting of nocturnal scenes, it was Manet who exerted the first and strongest influence on Munch's handling of outdoor scenes, after his arrival in Paris. This painting might be compared to Manet's *The Roadmenders* of 1878 (Fig. 18), wherein the same broad neutrality of colouring serves as a frame for a few flurries of asymmetrical activity, whose compositional centres can be hard to resolve. In this respect, Munch is not Manet's equal here, but he deftly assimilates such effects as cropping figures to provide rapid foreshortening, thus increasing tension and poise. This is seen in the four figures on the right and the barely decipherable couple on the extreme left. Munch uses this technique to enhance the sense of *reportage*, so important to Manet and Degas; the glistening puddles in the sunlit road indicate both the weather and their texture so vividly, that the generalized surfaces of the buildings present no difficulty; a masterly and economical use of paint. The massing of the crowd in the mid-distance is a prototype for the alarming groups that will soon be pressing up against the picture plane in later views of this street. The two amorphously-dressed girls, in blue and brown, scuffing a puddle, have a presentiment of this future development about them.

Fig. 18
Edouard Manet:
The Roadmenders,
Rue de Berne

1878. Canvas.
Fitzwilliam Museum,
Cambridge

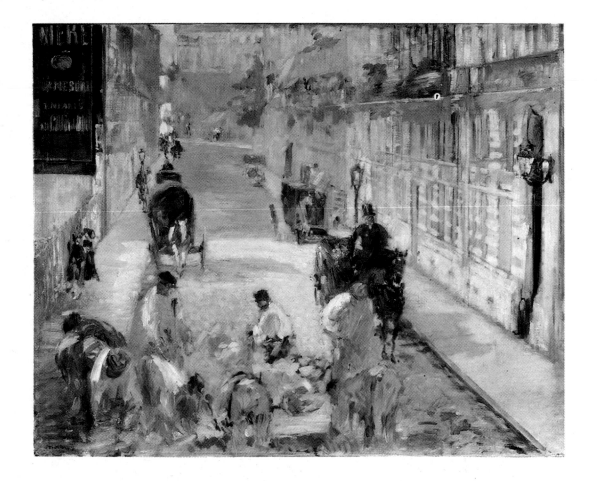

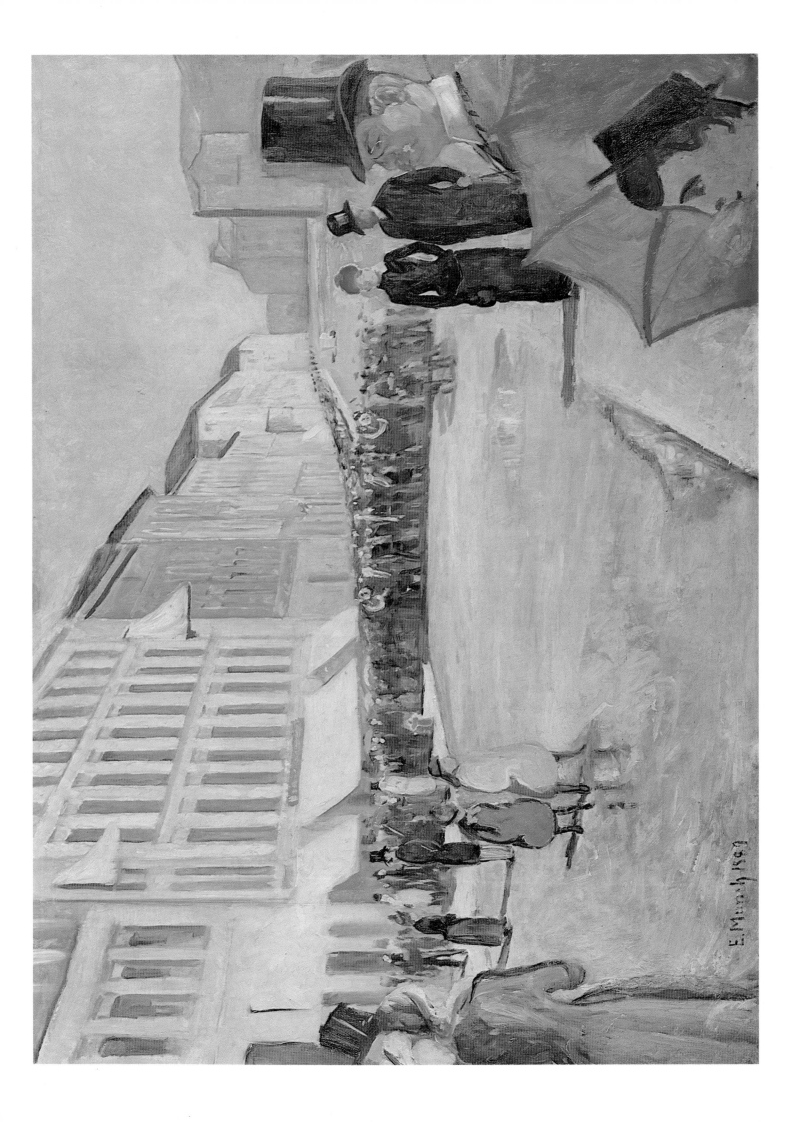

Spring Day on Karl Johan Street

1891. Canvas, 80 x 100 cm. Billedgalleri, Bergen

Seurat replaces Manet as the leading influence on Munch in this work. The fluid masses of the crowds now sparkle and glitter with the speckled application of contrasting warm and cool colours. Munch's emotive perception of the vigour and freshness of a spring day, however, breaks through the rationalist 'scientific' control of *pointillism* advocated by Seurat, and, as in the *pointillist* works by Van Gogh and Gauguin, impatience with the process produces inconsistent results over the surface – such as the trio, right of centre, who escape *pointillist* handling completely. In contrast to Pissarro, another influential exponent of *pointillism*, Munch sees the importance of maintaining a strong structure in order to impose a sense of depth; the greyish look *pointillism* often produces (which Seurat used to great effect in his late landscapes) can vitiate the power of form and lead to flaccidity. Munch's spontaneity avoids this pitfall.

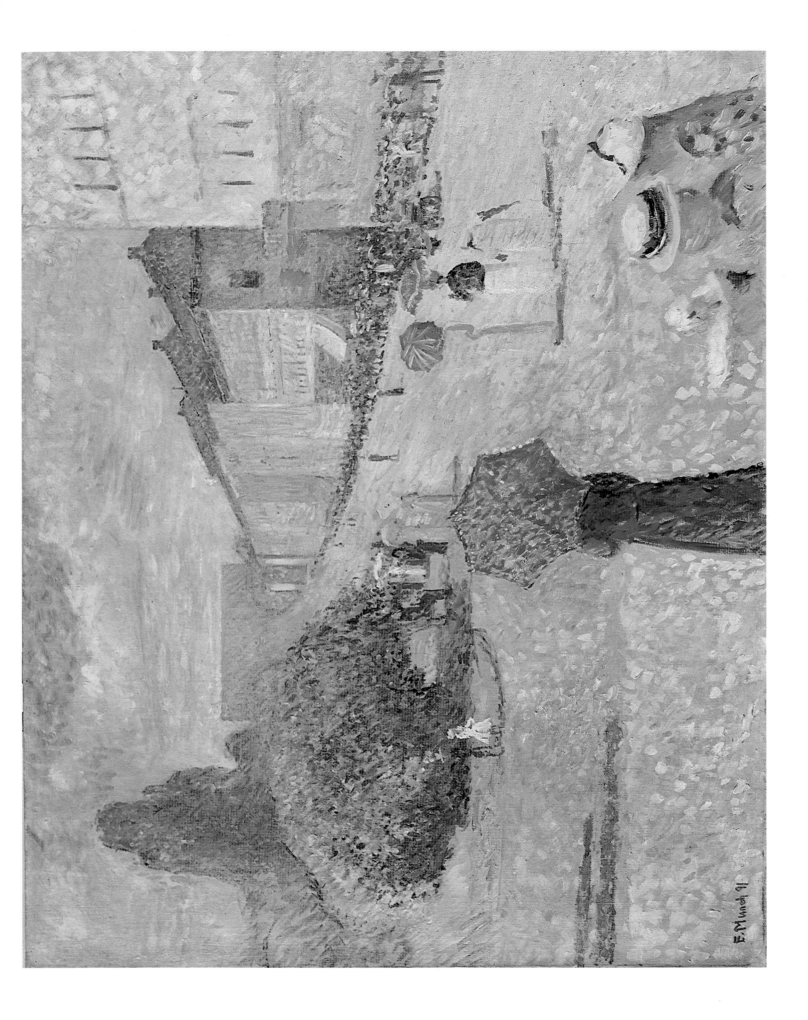

13 Evening on Karl Johan Street

1892. Canvas, 84.5 x 121 cm. Rasmus Meyers Samlinger, Bergen

This third view of Karl Johan Street faces in the opposite direction from the view in Plate 12 and the crowd is no longer a distant benign presence but a louring, looming force. The 'cropping' techniques of Degas, Japanese prints, and photography, provide Munch with a method of intimating threat and unease, as the vacant, pitiless gazes of the bourgeois strollers bear down on the viewer. The mood of nocturnal catalepsy comes from Munch's experience as he waited for a mistress to meet him: 'She greeted him with a soft smile and walked on … Everything became so empty and he felt so alone … People who passed by looked so strange and awkward and he felt as if they looked at him, stared at him, all these faces pale in the evening light.' Compared with *The Scream* (Plate 24), however, this work is still more symbolist than expressionist – the raw power of the latter hidden under the great beauty of the blue night sky and the glowing lamps, a velvet surface disguising the terror.

The single figure moving against the flow and walking in the middle of the street, evokes Munch's own situation as a 'bohemian' and radical artist, hounded by the middle-class authorities in the stifling parochialism of Christiania, in contrast with the larger world of Berlin, Paris and beyond for which he was yearning. Munch's mastery of symbolism, however, ensures that these personal interpretations do not intrude on the vision of universal anguish and every individual's fear of the mindless crowd. From 1896 Munch produced woodcuts with similar formations of conveyor-belt crowds under festering skies with more abstract titles such as *Anguish*.

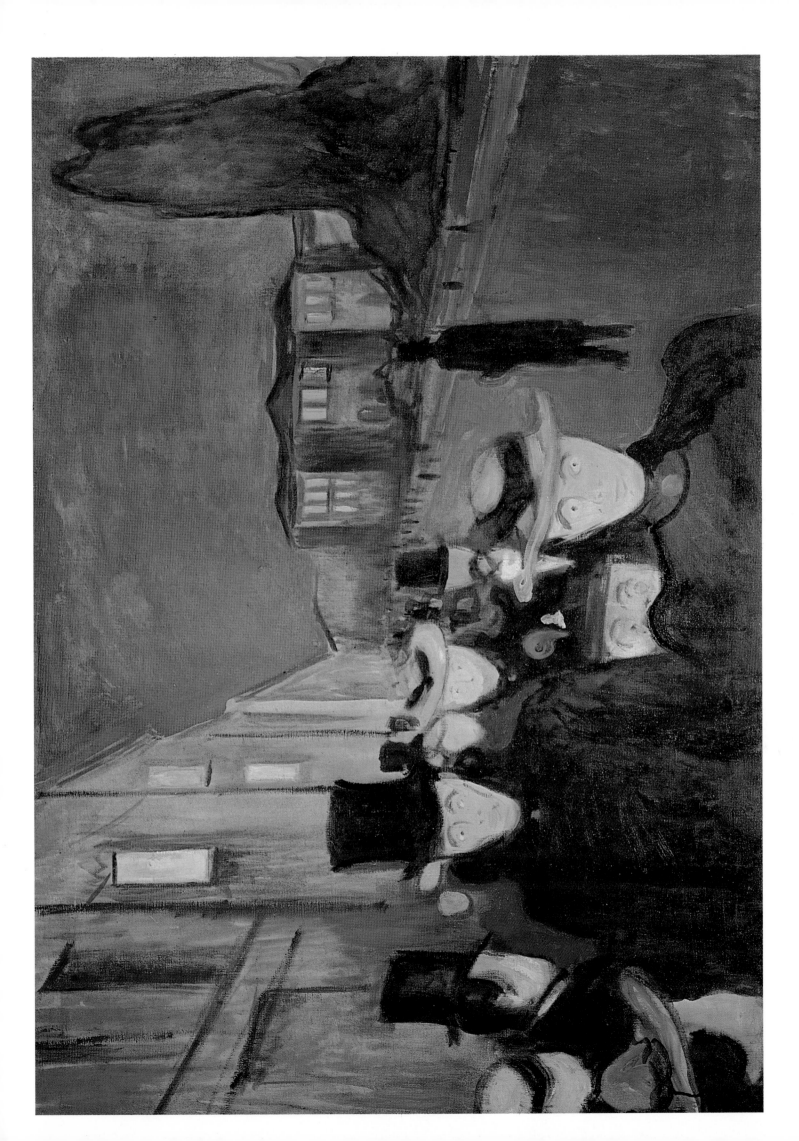

Portrait of Hans Jaeger

1889. Canvas, 109.5 x 84 cm. Nasjonalgalleriet, Oslo

A leading spokesman for the disaffected radical artists of the Christiania-Boheme, about which he wrote with such forthrightness and vigour that he was imprisoned for indecency and sedition, Hans Jaeger achieved notoriety in 1885. Together with the painter Krohg, who was so influential on Munch, he was determined to shock the bourgeois from their complacency, by indicting their intellectual laziness and corruption and their materialist greed. He advocated instead a life of vitality, honesty, and social and intellectual liberation.

Technically, this work has affinities with Munch's self-portrait of four years earlier (Plate 1), although more of the canvas has achieved definition and the melodramatic and theatrical element is less nervous. Instead of the artist's tense wariness, Jaeger regards the viewer with a confidence verging on arrogance. Austerity and asceticism are suggested by the sparse background, the sombre blues and browns, and the single glass, while the buttoned-up coat suggests defence against the outside world. The rakish angle of the hat ameliorates the severity, however, and the concentration on the figure's bulk in the modelling of the coat gives a realistic sense of presence.

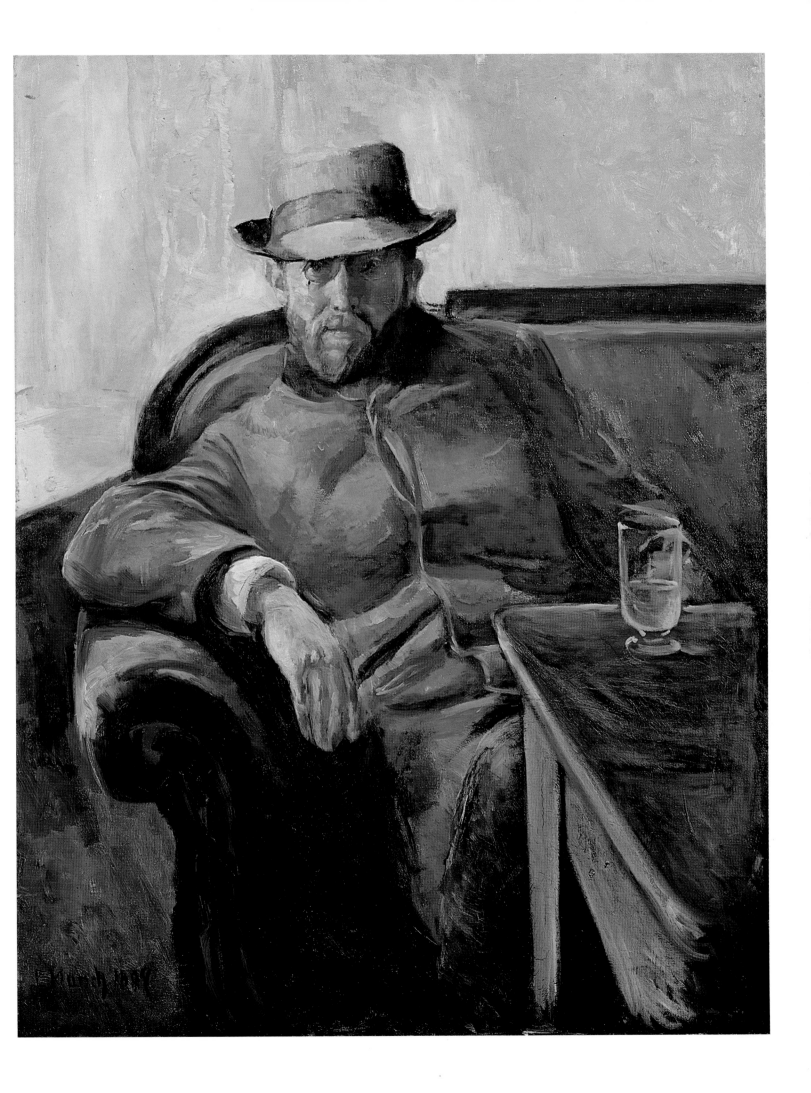

Portrait of the Artist's Sister, Inger

1892. Canvas, 172 x 122.5 cm. Nasjonalgalleriet, Oslo

The thinner, nearly translucent paint texture of this portrait, painted three years later than Plate 14, indicates Munch's relinquishing of naturalistic and realistic criteria in favour of emotional and idealistic concerns deriving from symbolism. The calm, almost iconic portrayal of his sister escapes blandness by subtle echoes of colour from the background, with its faint shadow; the off-centre placing of the figure; and the confidence with ambiguities of space deriving from study of the portraits of Whistler and Velázquez. The hieratic stance is also reminiscent of Holbein's portraits.

The simplicity of the modelling of the dress (the uniformity of the patterning is almost as flat as in paintings of this date by Vuillard and Bonnard), gives prominence to the clasped hands and the direct stare by increasing the paradoxical claustrophobia of the empty space. The sense of silhouette which results is derived from Gauguin's *cloisonné* outlining of forms against flat backgrounds. This pose will recur, more gloomily, in Plate 16.

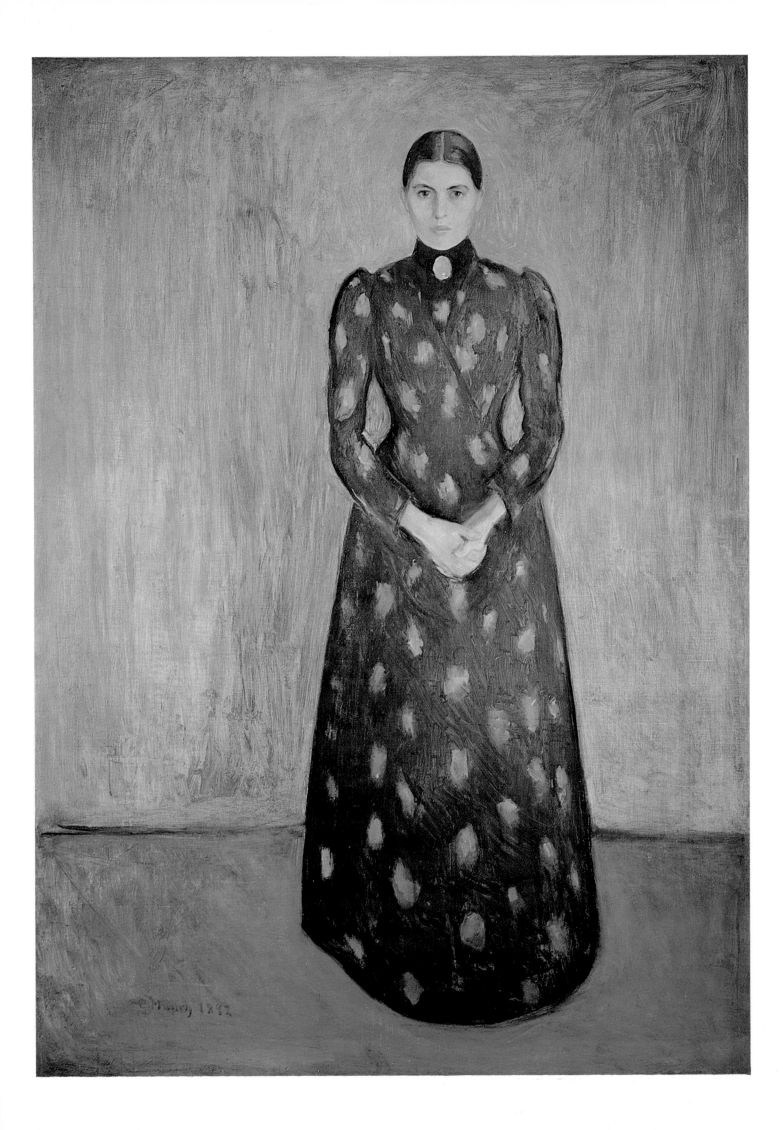

1893. Casein on canvas, 150 x 167.5 cm. Nasjonalgalleriet, Oslo

One of the paintings for his newly-envisaged *Frieze of Life*, his poem in paint of 'love, life and death', this work condenses the despair and anguish that Munch and his family experienced as a result of the ravages of tuberculosis: 'the illness followed me through all my childhood and youth – the germ of consumption placed its blood-red banner victoriously on the white hankerchief – my loved ones died one by one. One Christmas night I lay 13 years old – the blood running out of my mouth – the fever raging in my veins – the anxiety screaming inside of me. Now in the next moment you shall stand before the judgement – and you shall be doomed eternally …'. This protestant sentiment (revealed by Munch's praying father in the background) and its tone of terror may explain his rebellion in the ranks of the Christiania-Boheme. In this work, along with *The Deathbed* of the same year and *The Dead Mother and the Child*, recording his younger sister Sophie's shock and despair, the family is both isolated by grief, and unified through loss. The figure leaning against the door-jamb in the left background is thought to be Munch, while Inger stares haggardly out at us from the left foreground and the man with his back to her is their brother Andreas. The sickly green wall and etiolated black-framed picture are symbols of their exhaustion, as is the uncomfortable orange colour of the floor, which is reminiscent of Van Gogh's interiors. This colour scheme is repeated in other works on this theme.

Fig. 19
Death Agony

Lithograph, 39.3 x 50 cm.
Albertina, Vienna

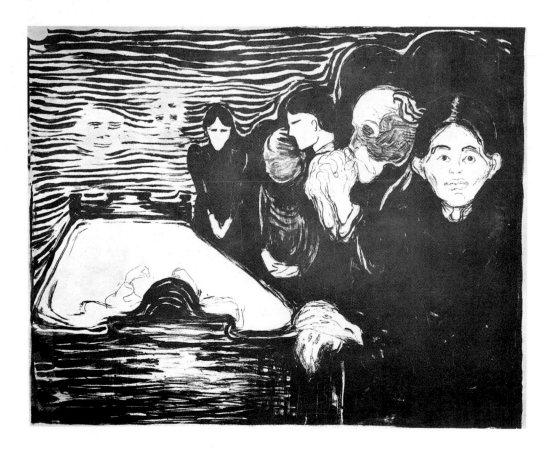

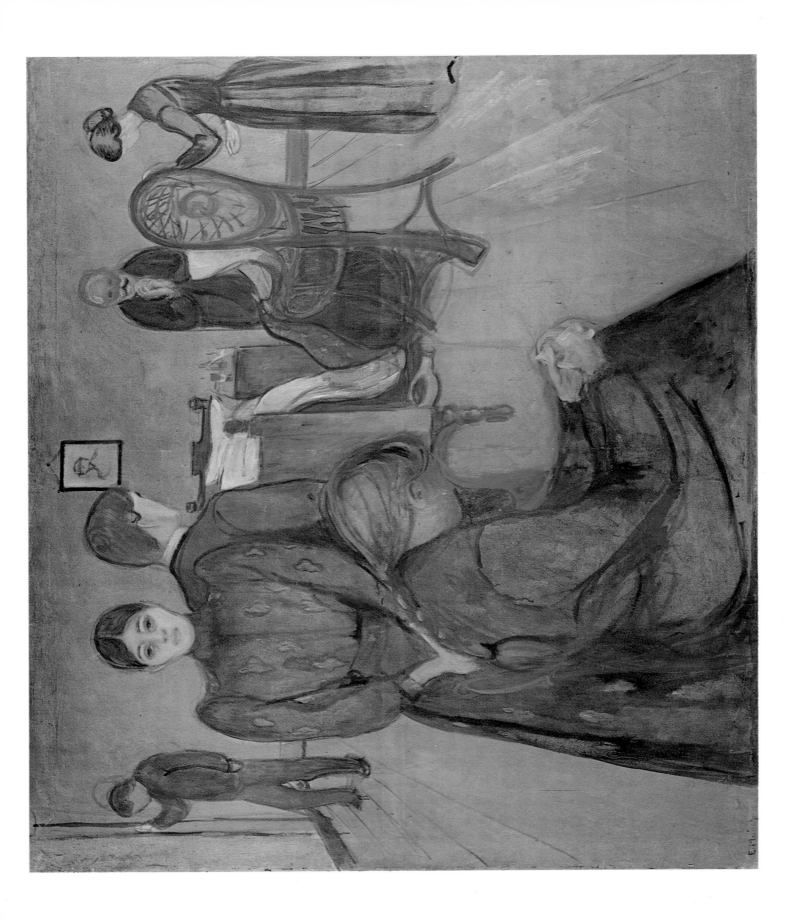

17 The Storm

1893. Canvas, 98 x 127 cm. Museum of Modern Art, New York.

Showing Åsgårdstrand, a beach resort fifty miles from Oslo where Munch spent his summers painting, this is an unusual representation of the place, which is normally a haven of peace in his work. It refers to a description of a great storm witnessed there by Jens Thiis, Munch's ally in Norway and director of the Oslo National Gallery. This *reportage* enabled Munch to symbolize the storm and its psychological effects. Undeniably dramatic, the impersonality of the figures, like a Greek Chorus, has a lot in common with the dramatic ethos of symbolism and the quest for 'universality' as found in the plays of Ibsen and Maeterlinck. The ambiguity of pose and gesture of the huddled, shadowy wives of the fisherfolk, stresses the fragility of the human compact with nature, and the lack of security in the face of its terrors, which are familiar to sea-going people. They have left the safety of the house, with its lights, and negotiate the treacherous darkness through the wind, which is indicated by the leaning tree and the scarf of the figure in white. Since the painting is primarily about the effects of nature on people, there is no need to show them cropped in the threatening manner of Plate 12.

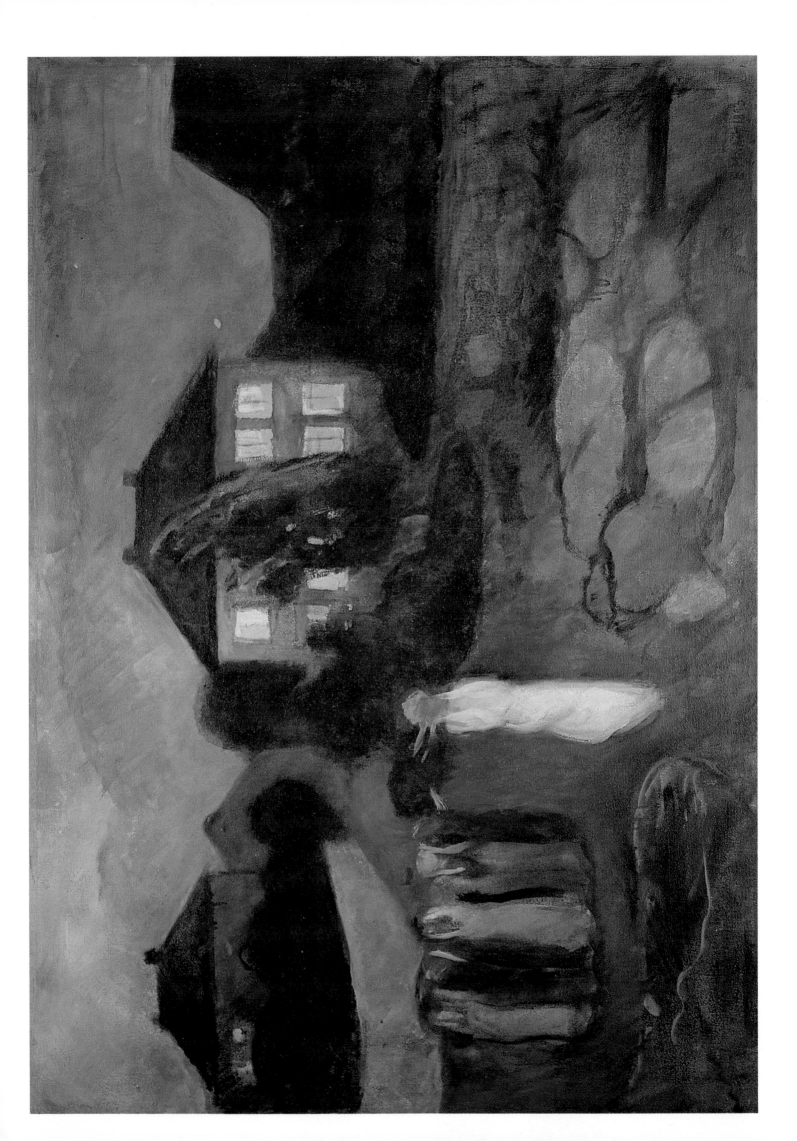

The Vampire

1895-1902. Lithograph and woodcut, 38.8 x 55.2 cm. Schiefler No.34. Munch-Museet, Oslo

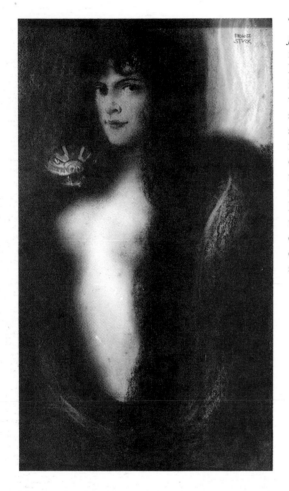

Fig. 20
Franz von Stuck:
Sin

1893. Canvas, 93 x 59 cm.
Neue Pinakothek, Munich

This is the most overt and unequivocal representation by Munch of the *femme fatale* motif so popular in the *fin-de-siècle* symbolist and 'decadent' milieus. Rossetti, Baudelaire, Maeterlinck (in *Pelleas and Melisande*) and Mallarmé all conjured with the *idée fixe* of strangulatory hair. Munch's originality lies in the impersonality of victim and attacker in an era abounding with Judiths, Salomés, and Messalinas. The wood block technique with its solid, chunky surface areas modulated by sinuous, wavering lines akin to art nouveau forms, gives conflicting signals, as does the scene itself; the fatal embrace, passively submitted to by the male, possesses a deceptive quality of floating gentleness. The muted colouring enhances this and only the straggling red streaks across the man's face suggest that something untoward is happening. This tripartite colour-scheme was often used by Munch in this medium; its unreality stressing the void in which the protagonists float, and making the work more psychological than physiological. The modernity of Munch's approach and the power gained thereby can be seen in comparison with Stuck's *Sin* (Fig. 20), where the exterior symbolism is so melodramatic as to make the image almost ludicrous.

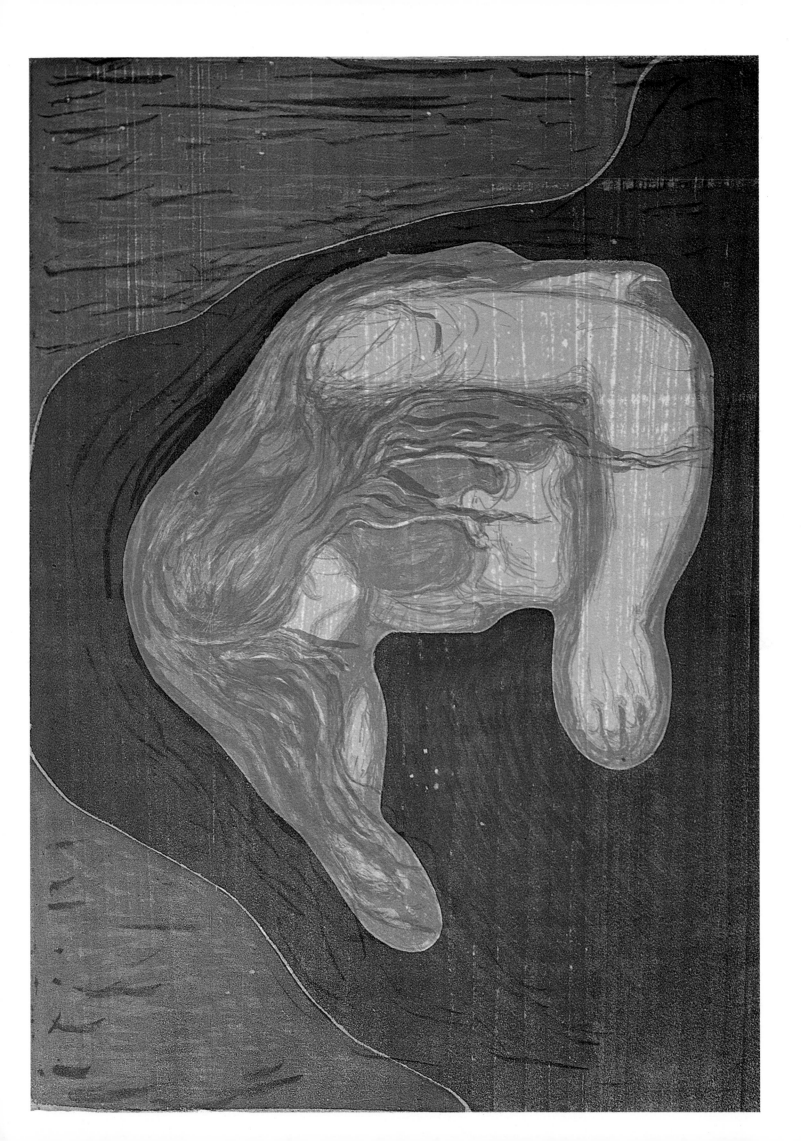

The Kiss

1892. Canvas, 73 x 92 cm. Nasjonalgalleriet, Oslo

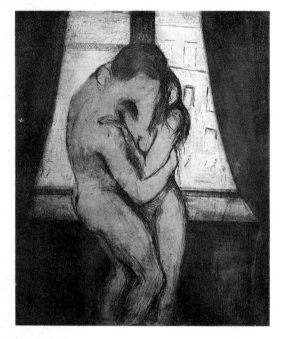

Fig. 21
The Kiss

1895. Drypoint and
aquatint, 343 x 278 cm.
Albertina, Vienna

The tonality of this painting and the shape of the window recall *Night in St Cloud* (Plate 9) and there is the same nebulous definition of form in the furtive couple on the right that gives such mystery to the earlier figure. This lack of solidity suits Munch's purpose, which is to portray the psychological sensation of a kiss, the 'melting together' of a couple into one, in accordance with idealist-symbolist theory, rather than a realistic or voyeuristic report.

In Figure 21, the two people are nude, their pose is less contorted, and they stand in almost exhibitionist openness at the window. They are modelled with a greater sense of volume, although there is a similar merging of the kissing faces. It is as if the repetition of the theme acted as therapy for Munch, producing confidence. In a hand-coloured woodblock print of 1897 the warm colours, brown and dark blue with pink-tinged flesh, give a more mellow impression; an early sketch dating from c.1889 is called *Adieu*; sad rather than celebrational.

The Kiss
It rained a warm rain
I took her around
the waist – she walks
slowly after
Two big eyes against
mine – a wet
cheek against mine
My lips sank into hers
the trees and the air and
All the earth vanished
And I looked into a new
World – I never
Before had known.

Munch notebook.

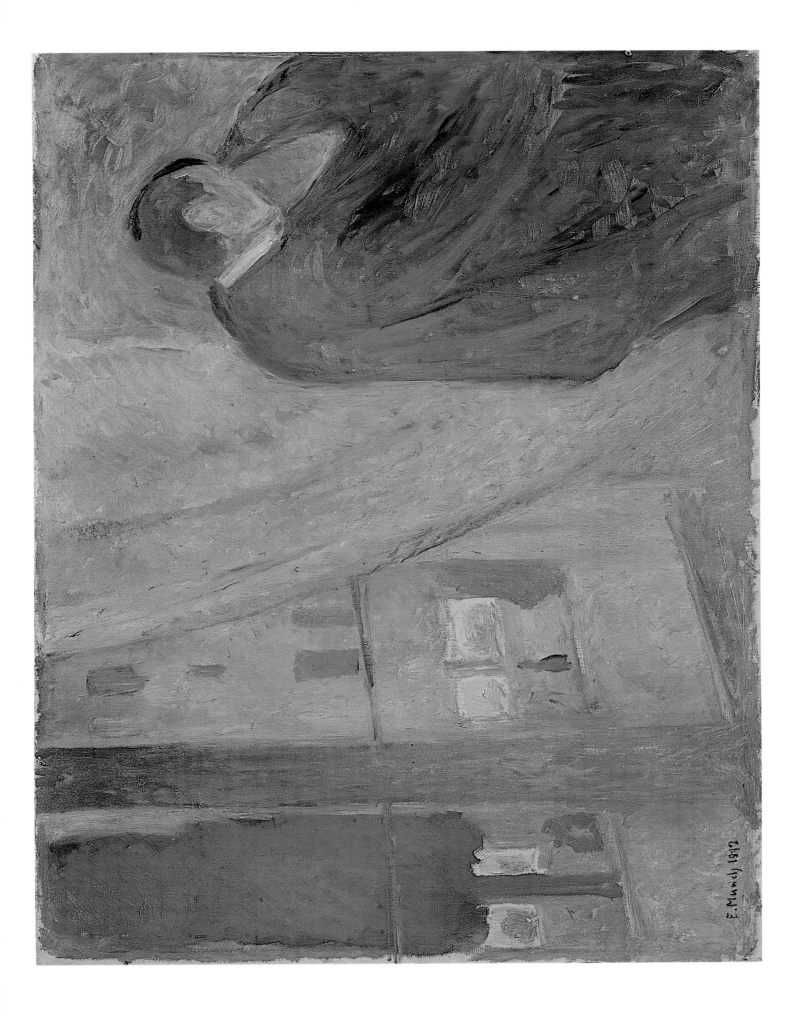

E. Mundy 1992

The Voice

c.1894-5. Canvas, 88 x 110 cm. Munch-Museet, Oslo

Two major versions of this composition exist, in several media. In the other version the woman is smaller and is elegantly portrayed in a white dress with her hair tied back and a calm expression on her slightly-projecting face. Her hands are behind her back and she looks relaxed but self-controlled. This is reflected in the peaceful view of Åsgårdstrand at night with the verticals of the pine trees cutting across the pale blue of the fjord over which floats the golden riband of the sun or moon which is just above the horizon. The other version, seen here, is more tempestuous; the shadow cast by the trees across her face is denser, and the paint itself more thickly applied and in darker tones. The top of her head is cropped by the frame and her bulk looms out at the viewer; the tension in her self-restrained arms is almost palpable. The greater impasto and emphatic modelling of the reflected moonlight increases the tense calm of the work.

The symbiosis between woman and nature is stressed by Munch who notes, 'and nature became nore beautiful because of you – through my retina … I saw the sea become vaster – the waves softer – the forest a darker green'. Munch also produced, at the same time, versions of the landscape without the figure, entitled *Moonlight* (Fig. 22).

Fig. 22
Moonlight

c.1894-5.

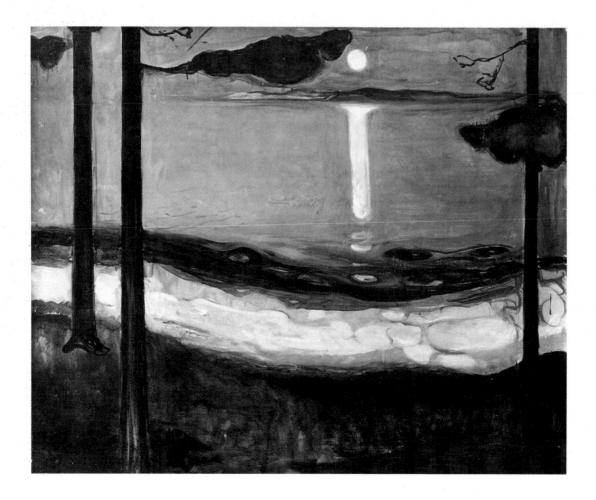

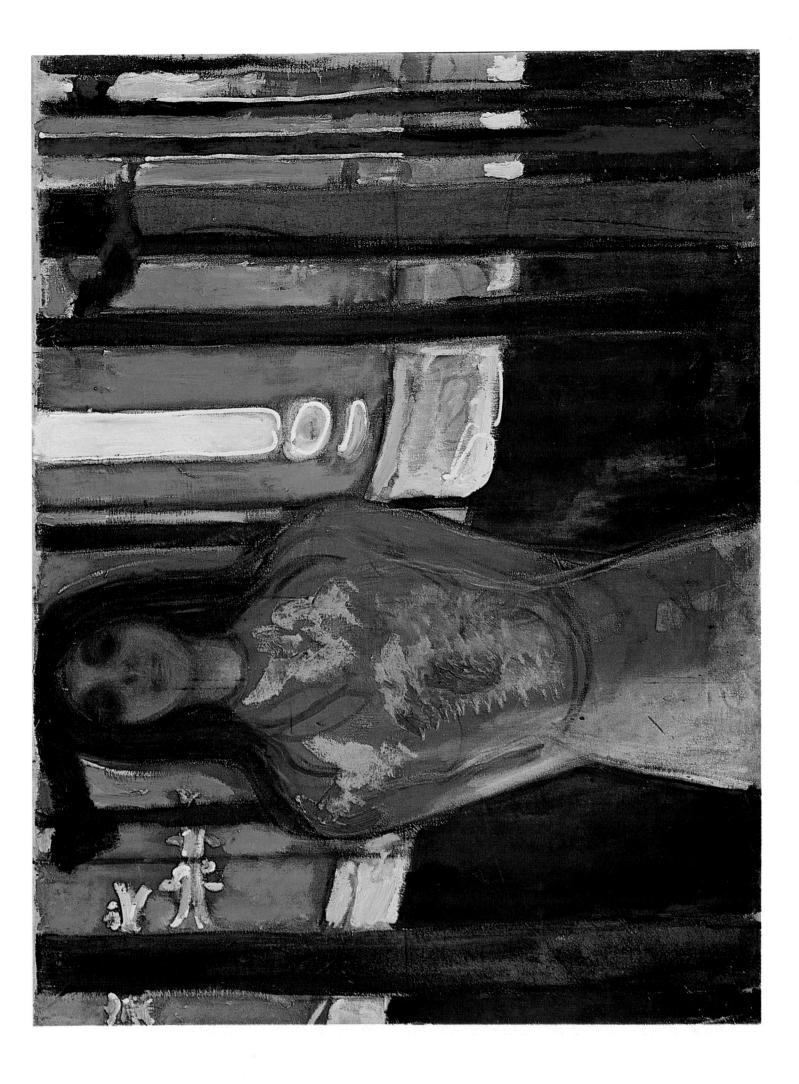

Melancholy

c.1892-3. Canvas, 64.5 x 96 cm. Nasjonalgalleriet, Oslo

As with Plate 20, various versions in several media exist of this composition, and the image of the despondent male isolated in nature was frequently used by Munch in the 1890s, sometimes with the added dimension of separation from a woman, as in this painting, *Ashes*, 1894 and *Separation*, 1895. In this version the man is reduced to little more than a head whereas in others he sits hunched like one of the boulders on the shore, staring blankly ahead of him. In the earliest versions, in ink, of about 1891, he is standing, downcast. Here there is a link between the figure in white on the jetty and the man, who has turned his back on the woman. This scene is referred to in a text by the artist:

> 'One evening I walked alone by the water – it sighed and swished between the stones – there were long grey clouds on the horizon – it was as if everything had died out ... a landscape of death – but then there was life over there by the wharf – there was a man and a woman ... and the boat was in place down there – ready to leave – She looks like her – I felt as if a sting in my breast – was she here now – but I know she is far away – have mercy on me – it must not be her'.

The striated clouds, a pattern familiar around the Norwegian coast, reoccur more strongly in *The Scream* and, as with so many works in *The Frieze of Life*, the powerful, undulating shoreline acts as the unifying compositional feature. The sense of bleakness as night or a storm approach is highlighted by the bright red of the pillars of the jetty and the boat. This duality stresses the ambiguity of Munch's approach to physical desire.

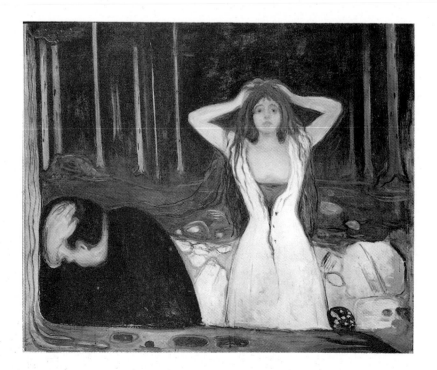

Fig. 23
Ashes

1894. Canvas,
120.5 x 141 cm.
Nasjonalgalleriet, Oslo

Madonna

c.1893. Canvas, 91 x 70.5 cm. Nasjonalgalleriet, Oslo

This work for *The Frieze of Life* derives from German symbolist versions of the *femme fatale*, such as Stuck's *Sin* and similar figures by Boecklin and Klinger, as well as iconic images by Rossetti in England. Munch eschews the ponderous allegorizing of these artists, however, by presenting a figure whose floating stance makes it difficult for the viewer to relate to her position; a halo or caul surrounds her, while only her arms define the depth of the picture space to any degree. The blank, impassive expression at once allures and repels; ambiguity is all. For Munch she is representative of the great fecund power of life; she is the vehicle through which it makes its way into the world. Munch suggests, from her facial features, that this is a virtually unconscious activity, undertaken in accordance with the higher dictates of evolutionary powers; 'in one of the corners of her mouth sits a spectre of death – in her two lips the joy of life'. The main thesis of *The Frieze* – that life and death are inseparable – receives its most potent illustration in this work.

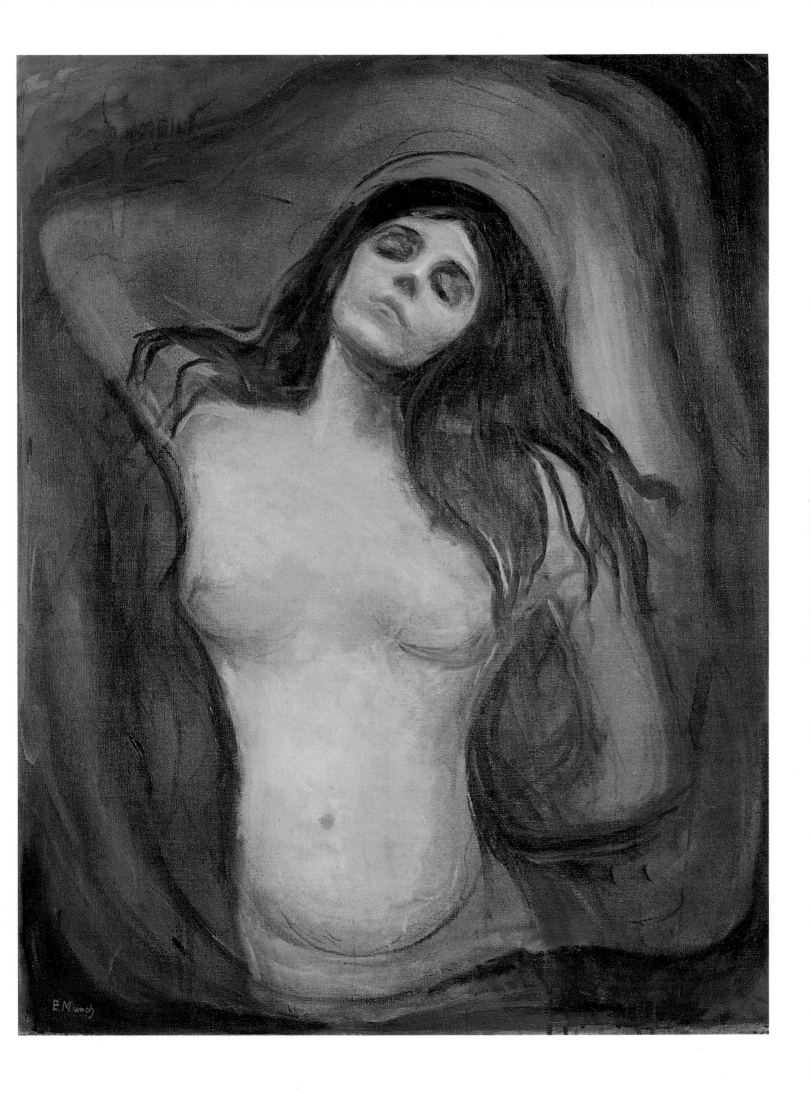

23 Madonna

1895-1902. Lithograph, 61 x 44.1 cm. Schiefler. No. 33. Munch-Museet, Oslo

The vaporously suggestive symbolist atmosphere of the oil-painting (Plate 22), reminiscent of the monochrome mysteries of Eugène Carrière (also a great portrayer of motherhood), undergoes a hardening in this later graphic version. The reference to birth and death as inseparables is more overt, with the frame of spermatozoa as an ironic commentary on the decorative frames painted by many symbolistics, such as Seurat and Whistler. The wizened foetus in the corner is derived from the embalmed body of a Peruvian baby, held in a Parisian museum, and probably known to Munch through Gauguin's use of its macabre shape in *The Grape Harvest at Arles. Anguish* of 1888. Its skull-head also appears in Munch's *The Scream* (Plate 24), and its 'primitivism' accords well with the stark impact of the black and red design, and the scratching and scraping on the shadowed areas of the woman's body.

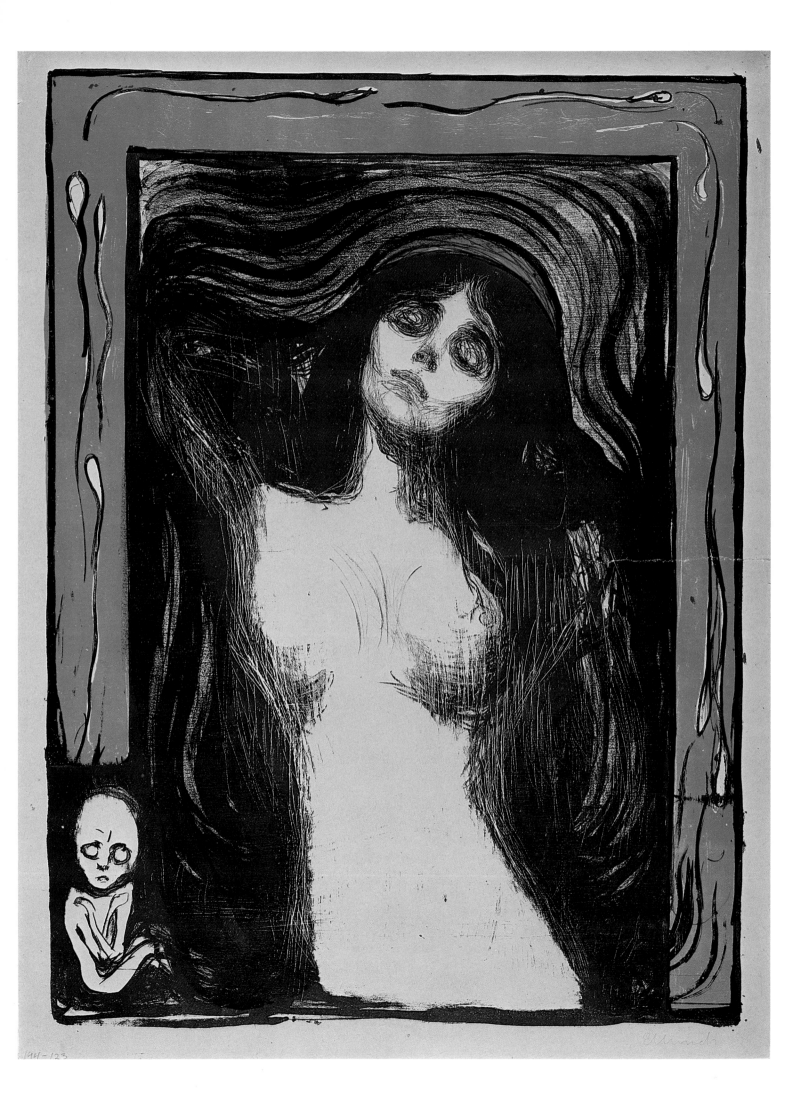

The Scream

1893. Oil, pastel and casein on cardboard, 91 x 73.5 cm. Nasjonalgalleriet, Oslo

In this painting, one of Munch's best known images, the etiolated figure writhes as though deafened by the searing sunset colours and pounded by the pressure of the waves of pain which Munch himself experienced. The scene achieves its mesmeric power through its basis in reality, and is a startling example of Munch's recollection and subsequent heightening of specific memories. Everything appears on the point of dissolution, but the reflected light off the lake, glowing in contrast to the land, is a natural observation at twilight, and so too is the pattern of the clouds.

The ghostly, nebulous quality of the cadaverous 'victim', and its companions in the distance, is replaced in the woodcuts that followed a few years later by a jagged, skeletal quality, in which the power of rhythmic design becomes all-important.

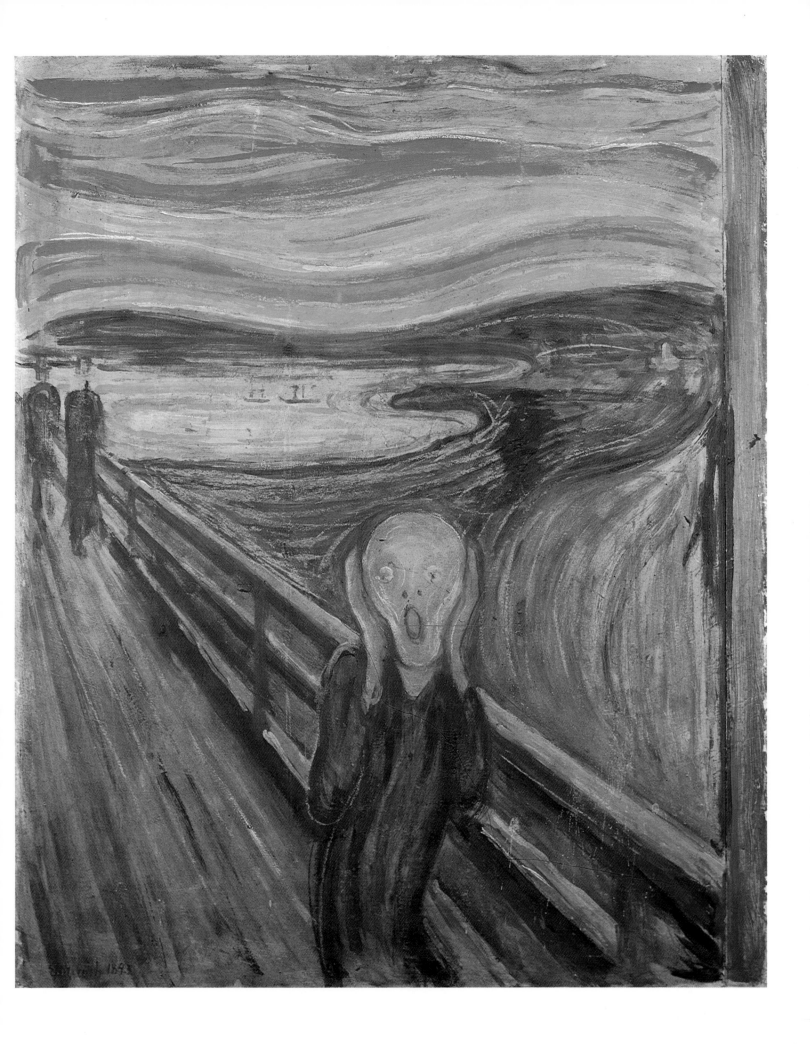

25 Fear

1896. Woodcut, 46 x 37.7 cm. Munch Museet, Oslo

Group anxiety and terror is the subject here, a development from the individual anguish of *The Scream*, and based on an earlier oil painting (Fig. 24). The stark simplicity of the colour-scheme, and the absense of naturalistic presentation, adds to the grotesque unreality of the bunched and threatening figures in evening dress. Like Ensor's contemporaneous paintings of masked figures and skeletons leading ordinary lives, Munch's lonely crowd is the more unnerving for its appearance of normality. It is a harsher assault on such society figures than the view of strolling crowds on Karl Johan street (Plate 13), since there at least the environment was fitting. Here it is hard to see how the coastal landscape and these city-dressed folk are supposed to cohere, unless they are forming a funeral procession.

Munch's method of slotting together various prepared wood blocks, each with different coloration, produces the combination of sharp detail in the faces, with the broad blocking-in of basic colour.

Fig. 24
Anxiety

c.1894. Canvas,
93 x 73 cm.
Kunstsammlung, Oslo

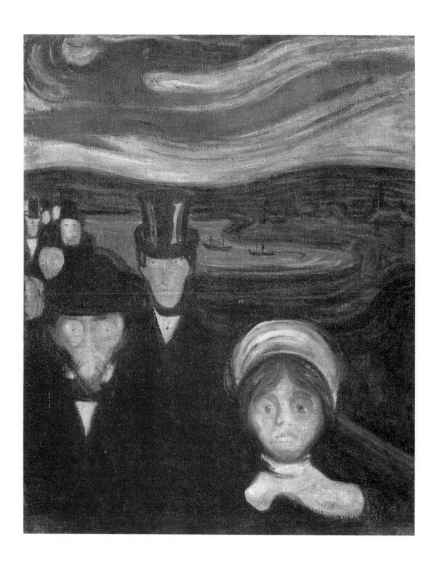

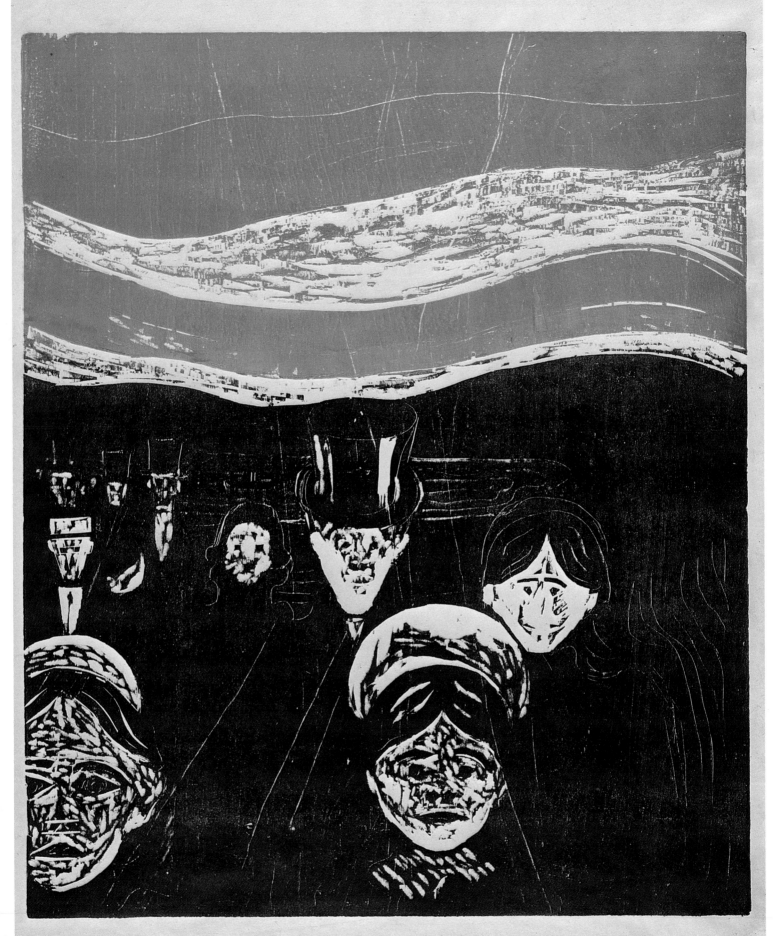

Edv Munch

Jealousy

1894-5. Canvas, 66.8 x 100 cm. Rasmus Meyers Samlinger, Bergen

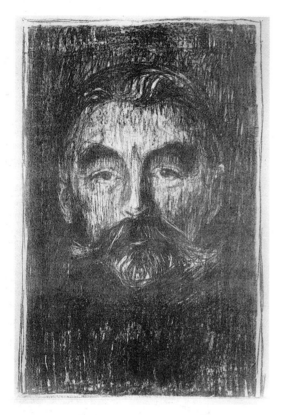

This is one of Munch's most overtly symbolist works, and dates from the height of the period in which his works were named after emotions (see Plate 25). Yet it is also one of the most autobiographical, and relates to his association with the group at the Little Black Piglet club in Berlin. The face looming out of the nebulous black foreground (his shoulders just discernible) is Stanislaw Przybyzewski, whose beautiful Norwegian wife Dagny Juell was the object not only of Munch's attention, but also of Strindberg and Meier-Graefe. This painting represents Munch's view of how her husband must have felt about this situation. The rich colouring and sensuality of the 'Eve' figure, in her flowing red dress, highlights the image of the anguished husband in a similar way to Gauguin's *Vision After The Sermon* (1888). The Edenic image is like a cartoon's 'thought-bubble'; the pair's generalized but rubicund features contrasting with the detailed pallor of the suffering figure in the foreground. The sensitively modelled features of the husband have an affinity with the delicacy Munch shows in his lithographic portrait of Mallarmé (Fig. 25).

Fig. 25
Mallarmé

1896. Lithograph,
401 x 289 cm. Municipal
collections, Olso

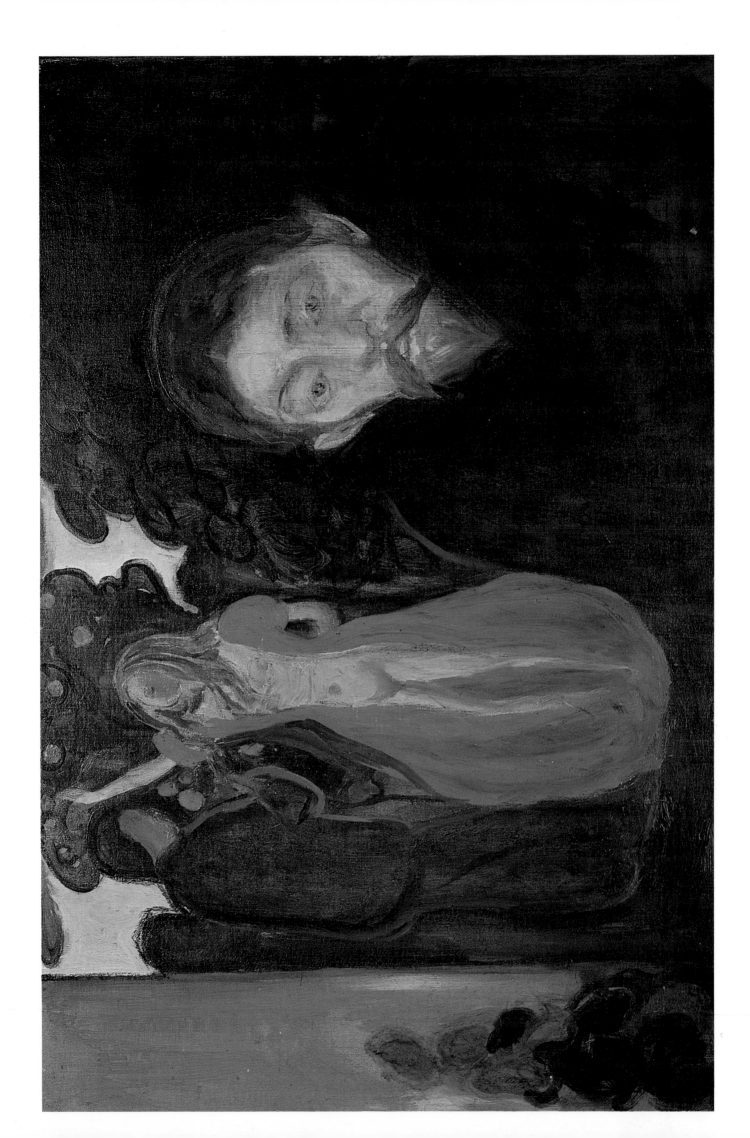

Mother and Daughter

c.1897. Canvas, 135 x 163 cm. Nasjonalgalleriet, Oslo

In Paris in 1896 Munch produced a programme illustration for Lugne-Poe's innovative production of Ibsen's *Peer Gynt*, in which Solveig and the aged Aase are boldly juxtaposed across the picture-space. Here the mood is less dramatic. Ostensibly the figures are Munch's sister Inger, and his aunt Karen Bjolstad who looked after the family following his mother's death. The landscape is gently oppressive, with its high horizon sloping sharply to the left, and the flaring red tendrils of plant growth on the right. In contrast with the flowing art nouveau or Jugendstil quality of the background, the rigidity of the figures suggests partly an interrupted quarrel, and partly an attempt by the artist to escape the merely circumstantial by introducing an elemental depiction of opposites: black against white; sitting and standing; and the extraordinary line of tension where white and black dress meet, crystallizing out in red and blue. In true symbolist style the mystery of the behaviour which motivated the composition is not divulged.

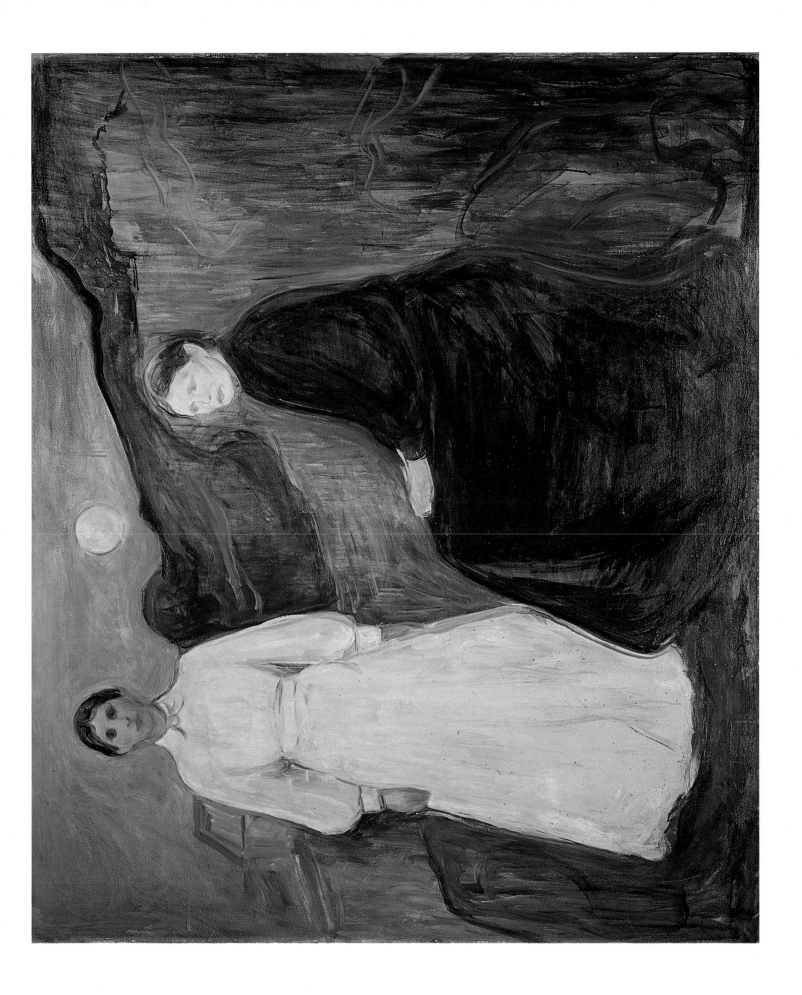

Moonlight

1896. Woodcut, 41 x 46.9 cm. Schiefler No.81. Munch-Museet, Oslo

This painting derives from an oil painting of about 1893, but here, in contrast to that work, the central image occupies more of the picture space and the naturalistic elements in the background are pared away. The romantic subject, so dear to the symbolists for its evocation of gentle mystery, and consisting here of a lone woman beside a house in a nocturnal setting, is made starker by the wood-grain on her face, although her features are delicately modelled, and by the attenuated vegetation on the right. Contrasts of colour are sharper than in the carefully modulated lyricism of the oil painting, which makes great play with the ambiguity of moonlit space. The predominance of black makes this one of the most dense of Munch's graphic works, and this in turn creates an impressive sense of sadness in the woman's features. The bluntness of the carving was to be an important influence on the Bruecke artists in Germany a decade later.

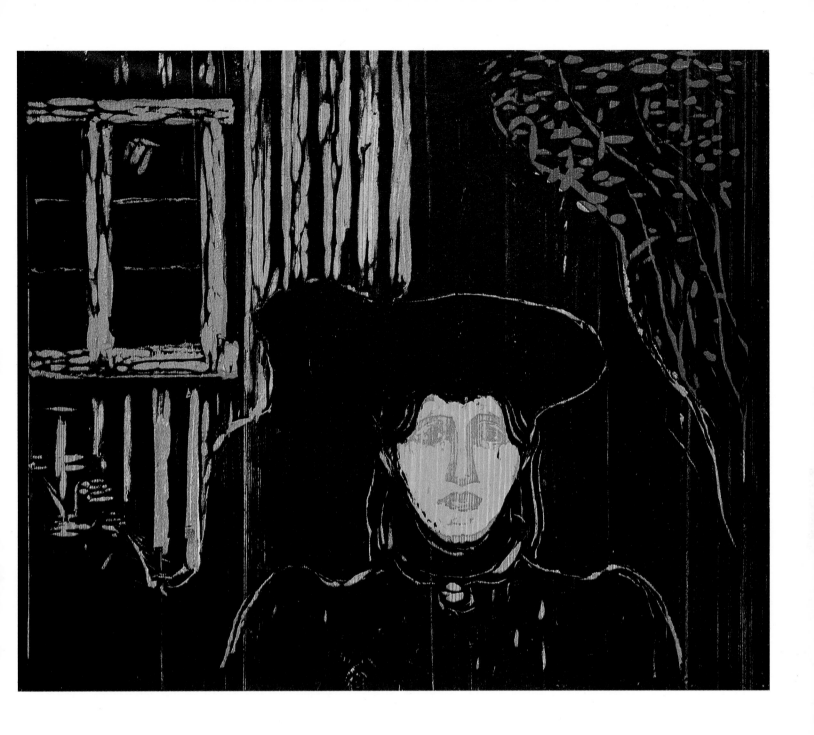

Melancholy

1896. Woodcut, 37.6 x 45.5 cm. Munch-Museet, Oslo

Down here on the beach I seem
to find an image of my-
self – of my life –
Is it because
it was by the beach
we walked together that day?
– The singular smell of seaweed
also reminds me of her
– the strange rocks which mystically
rise above the water and take
the forms of marvellous creatures
which that evening resembled trolls –
In the dark green
water I see the colours of her
eyes –
way way out there – the
soft line where air meets
ocean – it is incomprehensible – as
existence – incomprehensible as
death – eternal as longing

This woodblock derives from Plate 21 and, as in the previous plate, the central motif gains in power and focus, even though the realism of the work is less apparent. It is one of Munch's most successful depictions of man's psychological state combined with the objective relationships inherent in the landscape, with its brooding black and dark green over which flares the sky 'dripping with blood', as Munch put it. As with many *Frieze of Life* works, the tension of the piece is maintained by the sinuous boundary between land and sea, itself continuously in flux. Munch suggests that mankind's emotional life reflects the wild yet structured ebb and flow of the tides. Many variations of this plate exist, with gentler versions in blue, yellow, and green among them.

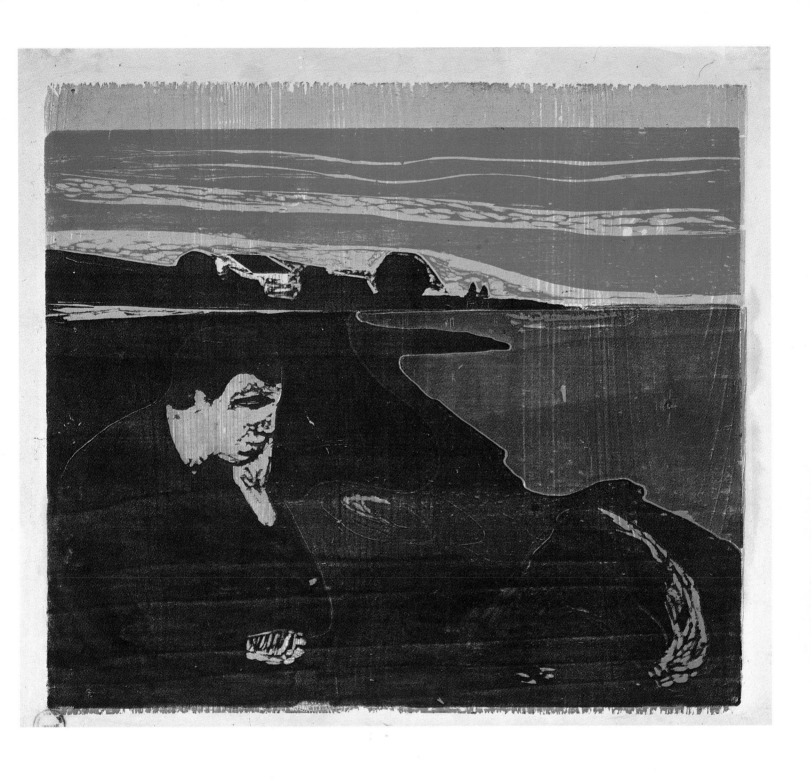

Melancholy (Laura)

1899. Oil on canvas, 110 x 126 cm. Munch-Museet, Oslo

Munch's sister Laura declined into madness in later life and in doing so reminded him of the fate he always felt he had just avoided. In comparison with the portraits of Inger, there is a quality about the dense painting of Laura's face which suggests that Munch was ill at ease with the implications of the subject. His later portrait of Friedrich Nietszche, painted from a photograph in about 1906, has a similar stiffness. The latter's descent into madness in 1889 would have been seen by Munch as a cautionary tale, particularly as syphilis was cited as a primary cause of Nietszche's madness, and the 'free love' life-style of the Christiania-Boheme courted that risk inordinately.

With Laura we are presented, unlike in Plate 29, with an interior world failing to relate to the exterior world. Laura stares vacantly past the potted plant, which looks unnatural on the seething tablecloth; her large red fists lumpenly useless. The heavy linear moulding of her shoulders against the familiar grid-like and imprisoning window-panes (and their shadows) implies the caged mind of the sitter in a way which makes the view of the distant beach deeply poignant.

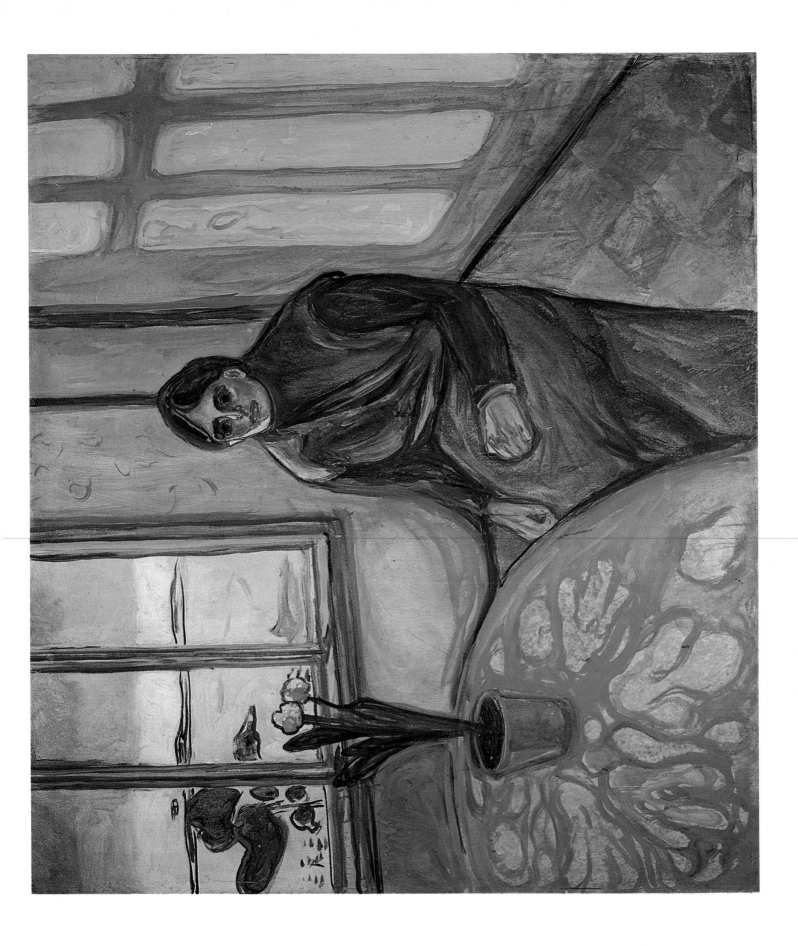

Girls on the Bridge

1920. Coloured woodcut and lithograph, 50 x 43.2 cm. Private collection

This woodcut with lithograph is one of many variants of a justly popular subject. It is adapted both from *Girls on the Jetty* (Plate 34) and from an oil-painting, *White Night* (1903), which is now in Moscow. The organic meshing of the buildings and trees in the background, forcefully linked by the bridge to the elegant and attractive subject, is rarely bettered in Munch's oeuvre. The mass of the tree is adapted from *Starry Night* of 1893 (Fig. 31), the source for a number of such motifs, but is seen here in the clear light of day. It is hard to find a parallel in technical accomplishment anywhere else in Munch's work. Influences from the graphic work of Schmitt-Rottluff and Kirchner are evident, including the more easy-going, even hedonistic appreciation of youthful life in the countryside. Variants occur, however, in which the nearest girl turns towards us with an expression of horror as though to remind us that demons still lurk within.

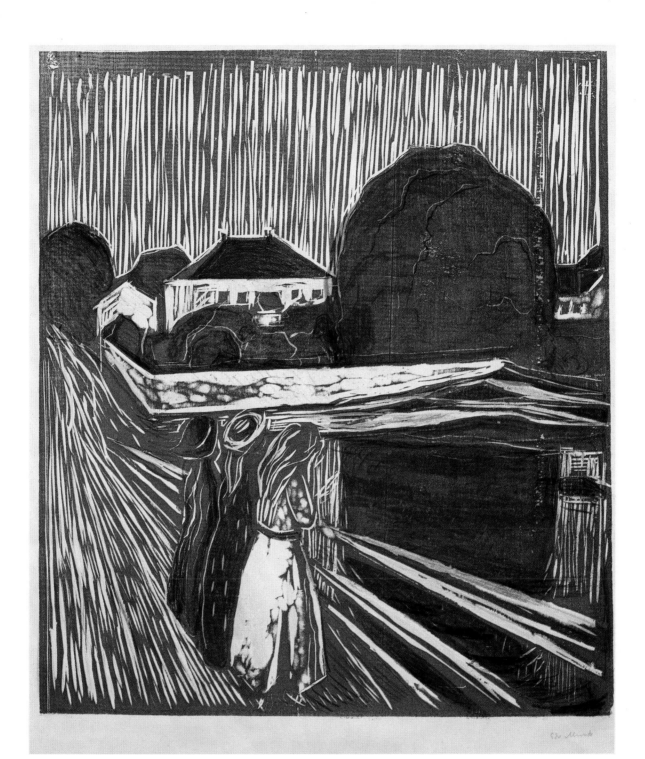

The Dance of Life

1899-1900. Canvas, 125.5 x 190.5 cm. Nasjonalgalleriet, Oslo

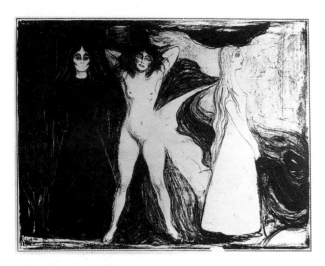

Fig. 26
The Three Ages of Woman

1899. Lithograph,
460 x 595 cm.
Albertina, Vienna

I started a new picture
The Dance Of Life –
In the middle of a field
on a light summernight
a young minister
dances with a woman
with loosely hanging hair –
They look into
each other's eyes …
Behind them a wild crowd
of people are whirling –
fat men biting women
in the neck –
Caricatures of strong men
embracing the women –

Munch's account suggests that the autobiographical source for this, one of his most symbolist-philosophical works, was the celebration of midsummer nights at Åsgårdstrand on the southern coast of Norway, where he spent most of the summers of this decade. A pen and ink sketch stresses the caricatural and incidental nature of the original scene, but the oil painting is altogether more portentous, with its allegorical division of the women into the three stages of love that Munch discerned: the virginal and hopeful girl on the left, advancing with arms outstretched and with radiant golden hair in the evening light; the red-dressed dancer, like the figure of Eve in *Jealousy* (Plate 26), who has tasted of knowledge and power and is using them to the full while she can; and the figure in black on the right, who is gazing in anguished yearning at the dancing couple, and has her hands clenched tightly in front of her. Although schematic, as in related works such as *The Three Ages of Woman* (Fig. 26), there is great power in Munch's evocation here of the 'biological clock'.

The grimacing, mask-like face bearing down on the flinching white-dressed girl on the right has affinities with sixteenth-century German images of Death dancing with a young maiden.

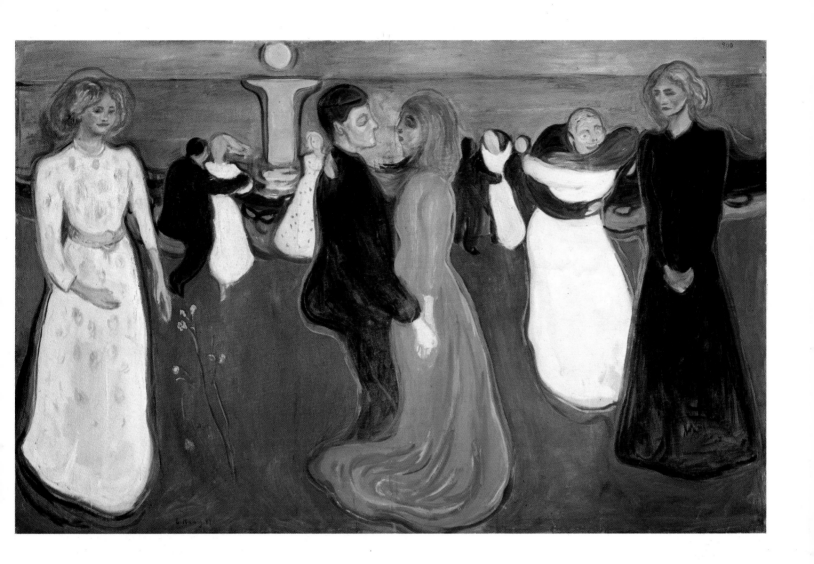

The Dance on the Shore

1900-2. Canvas, 95.5 x 98.5 cm. Narodni Gallery, Prague

As with Gauguin's parallel 'manifesto' work, *Where do we come from? Who are we? Where are we going?* (1897), Munch's completion of the central image of the *Frieze* (Plate 32) meant that greater ease and fluency could emerge in subsequent works as the pressure of expression lessened. This is shown by the new richness and delicacy in the handling of paint, the modulation of colour, and the harmonious intertwining of human and natural motifs in this work. The calm of the moonlight shining on the gently incoming waves, echoes the bright whirling forms of the girls, white and yellow, circling at the joining point of land and sea, as though at ease with both. The cleft in the land echoes the band of moonlight, and the curving arch of the trees guides the eye down to the shore without obscuring the mysterious dark-clothed figures in the shadows on the right. These black figures are no more than small reminders of the tensions in the previous plate, reduced here to manageable proportions yet providing just the right amount of discordance in order to allay blandness. Munch used this theme in the frieze he designed for Max Reinhardt's 'Kammertheater' in 1906-7.

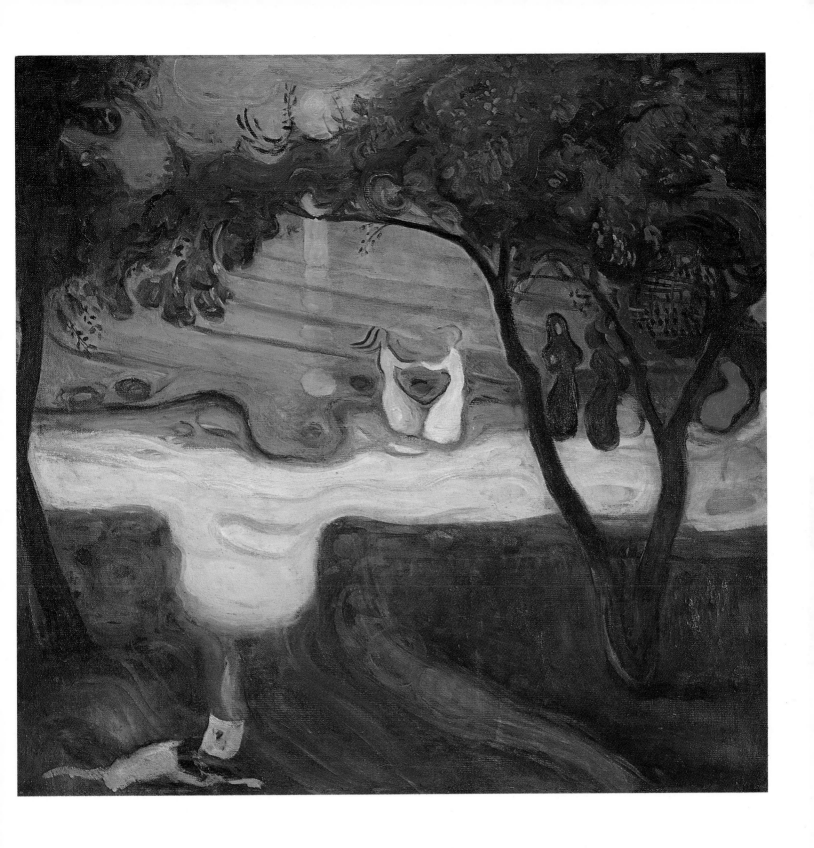

Girls on the Jetty

c.1899-1901. Canvas, 136 x 125.5 cm. Nasjonalgalleriet, Oslo

As in the previous plate, a new benignity is present in the accomplished balance of the brushstrokes, and the finely judged arrangement of colours of this simple and memorable design. The familiar device of a steep diagonal pulling the viewer into the picture does not produce vertigo, as in *The Scream*, but introduces us to the three girls, in warm complementary colours, staring into the calm waters in a pose redolent of contemporary symbolism and art nouveau. The unity of the girls is set against the unity of the white-walled house sheltered by the dark green trees. The pale shimmering blue of the summer sky gives a note of mystery; but here the protagonists are at ease with themselves and their surroundings, full of the lyrical calm that predominates in Munch's work at the turn of the century. It is as though Munch can contemplate the girls without the tension and fear caused by desire intruding.

The woodcut version, (Plate 31), is by the nature of the medium more exuberant and less reflective than the oil painting. In 1903 he produced an engraved variant that reintroduces anguish, as the nearest girl turns towards us with a look of abject terror.

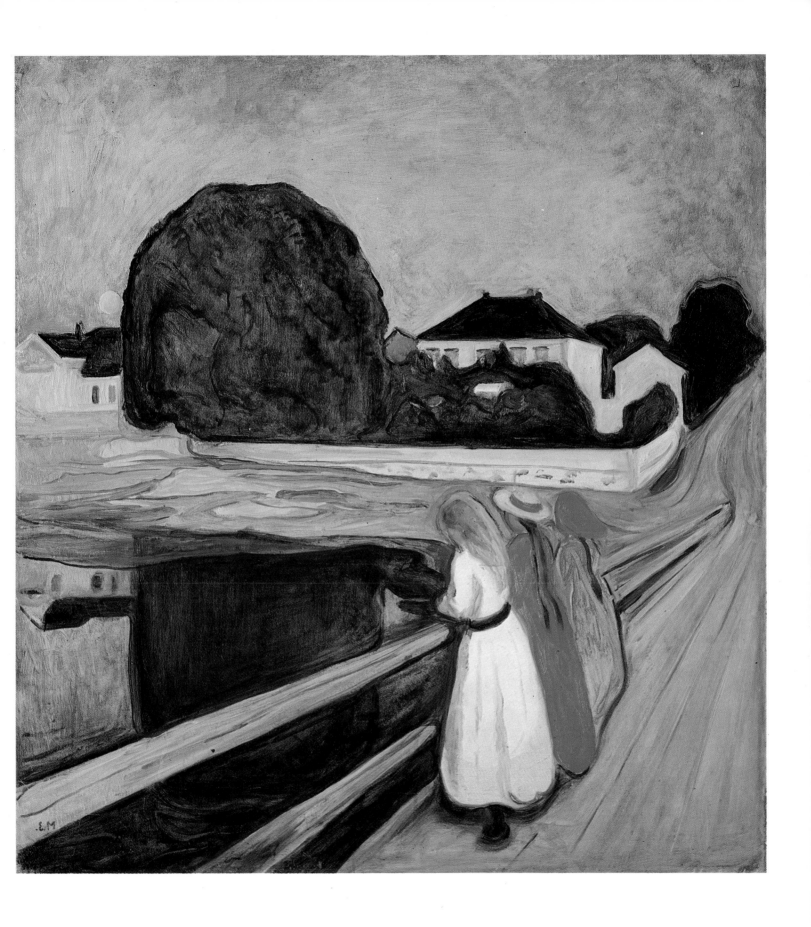

35 White Night

1901. Canvas, 115.5 x 110.5 cm. Nasjonalgalleriet, Oslo

This painting is one of the best-loved evocations of Norwegian landscape. The tensions of the previous decade have been resolved and the miasmic qualities of *Starry Night*, which gave it a mysterious symbolist splendour, here become a frozen, glittering clarity, modulated by the forms of the trees in a panoramic view. This was a format to which Munch repeatedly returned (see Plate 46). The subtlety of the bands of colour in the sky and the differing textures of the paint used to represent it, reveal a new power of observation, while the removal of a human presence allows an expansiveness to emerge. Munch was not alone in such explorations. The Swiss artist Ferdinand Hodler, also influenced by symbolist concepts, transformed picture postcard views of the Alpine Lakes into strikingly vivid displays of light and colour, with a powerful symmetry linking air, earth and water. Munch attempts something less programmatic here, but both artists were drawing on the German Romantic tradition of philosophical-religious landscape painting proposed by C.D.Friedrich and his pupils from 1810-60.

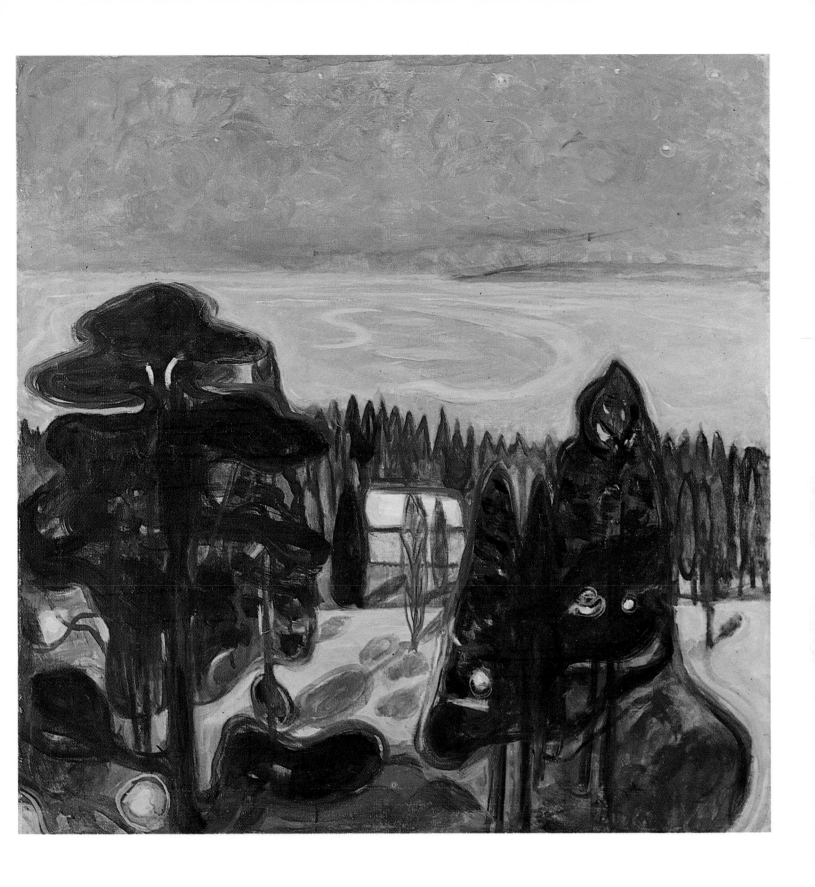

The Four Sons of Dr Max Linde

1903. Canvas, 144 x 199.5 cm. Museum, Luebeck

Dr Linde was a renowned eye specialist and was one of the group of wealthy, cultured Germans who welcomed Munch in the 1890s, and particularly after his breakthrough exhibition in 1902. Munch was having difficulties with his Norwegian friends at this time and the German connection provided solace and hospitality. Furthermore, Linde and others were avid and perceptive collectors of modern art.

The composition of this painting is a more successful variant of the frieze-design employed for *Four Girls at Åsgårdstrand*, 1902 (Fig. 27), where the dour colouring of the girls in their best clothes diminishes the impact. Here, in their smart sailor-suits against a white background, the children each have an identity, while at the same time forming a group-portrait. There are typically Munchian elements in the poses: one boy holds his hands self-consciously in front of him, while the boy on the right pretending insouciance, has one hand behind his back, and toys with his straw-hat. As with the Åsgårdstrand work, Munch's skill lies in his portrayal of the fact that the children are merely waiting to be released from posing in order to go out and play again. This awareness enables him to avoid the sentimentality which haunts many nineteenth-century children's portraits. This is largely achieved through the bold patterns produced by the broad white bands and the rhythmic variations of blue-black arms and legs.

Fig. 27
Four Girls at
Åsgårdstrand

1902. Canvas,
89.5 x 125.5 cm.
Staatsgalerie, Stuttgart

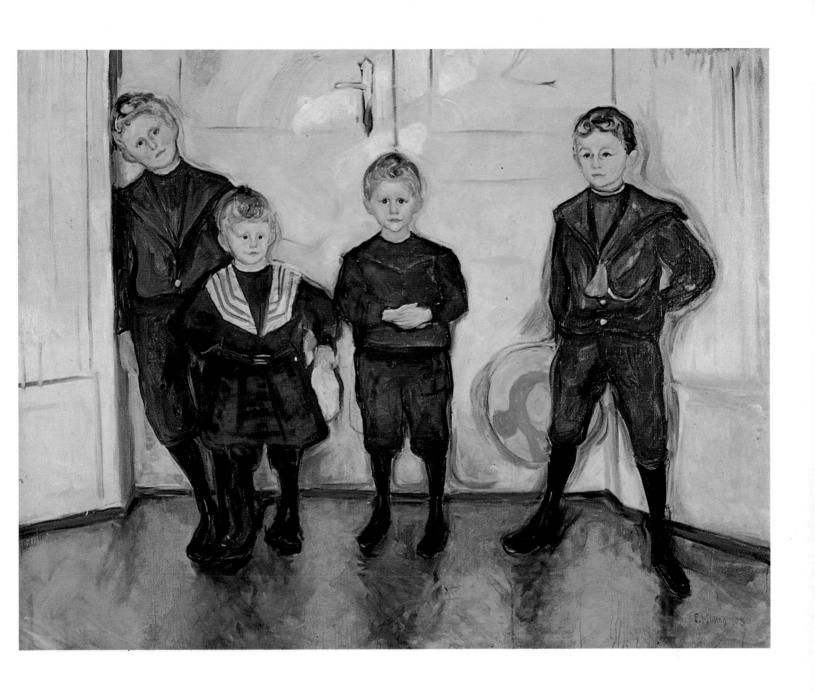

Portrait of Walter Rathenau

1907. Canvas, 220 x 110 cm. Rasmus Meyers Samlinger, Bergen

The industrialist and politician Walter Rathenau was another of Munch's German supporters. He was at the height of his fame when this portrait was painted, and his arrogance and pride, which gained him many enemies, are palpable. As he commented: 'An awful character, isn't he? That's what you get for having your portrait done by a great artist – you look more like yourself than you really are.' Rathenau was to become famous as the organizer of Germany's economy in the Great War which enabled it to withstood the Allied blocade for over four years. He later showed considerable skill in restoring industrial and political confidence in the defeated country, but he was blamed, unfairly, for the defeat of the German military and was assassinated by right-wing fanatics in 1922. This painting is the second version of the two portraits of Rathenau which Munch produced and the effect of the glistening patent-leather shoes, and the man-of-the-world pose, reveal that for all his apparent symbolist insecurity and Nordic introspection, Munch could depict power as effectively as any of his contemporaries at the turn of the century.

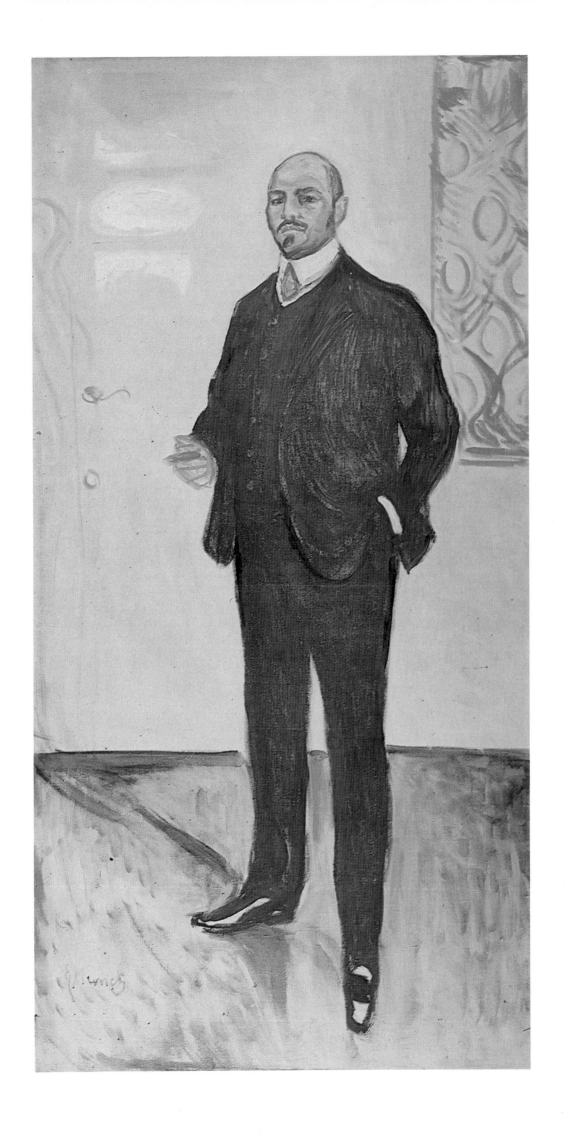

Death of Marat

1907. Canvas, 151 x 148 cm. Munch-Museet, Oslo

After 1906, the year of *Self-portrait with Wine Bottle* (Fig. 28) which is full of insecurity and introspection, a change occured in Munch's technique: 'I had the urge to break areas and lines – I felt that this way of painting might become a manner ... Afterwards I painted a series of pictures with pronounced broad lines of stripes, often a metre long, running in verticals, horizontals or diagonals'.

A new symbolism is broached, overt and classical as in *Amor and Psyche*, or historical as here. The status and role of the sexes are paramount, as the subjects suggest, and the culmination here is violence and murder. David's original painting of 1793 depicted Marat as a martyr for the French Revolution; perhaps Munch is suggesting that the self-portrait-like figure here is a martyr for the 'Christiania-Boheme' concept of free-love. Whatever the message, it is bloody in result, and the expressive brush-strokes, influenced by the techniques of the Die Bruecke expressionist group, enhance this. Horizontal and vertical axes indicate the opposed will-power of the two figures; the *femme fatale*, named as Charlotte Corday in history, is triumphant, and presumably stands calmly awaiting arrest, as did her French precursor. In a wider context the painting demonstrates Munch's abiding concern with the inextricable claims of love and death.

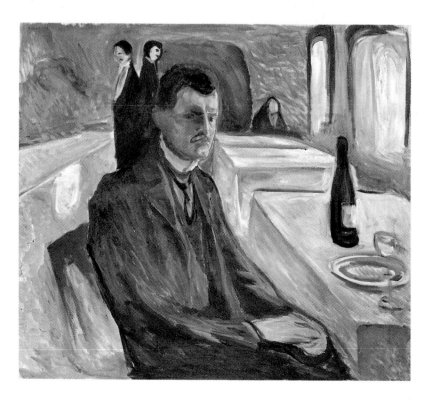

Fig. 28
Self-portrait with Wine-Bottle

1906. Canvas,
110.5 x 120.5 cm.
Munch-Museet, Oslo

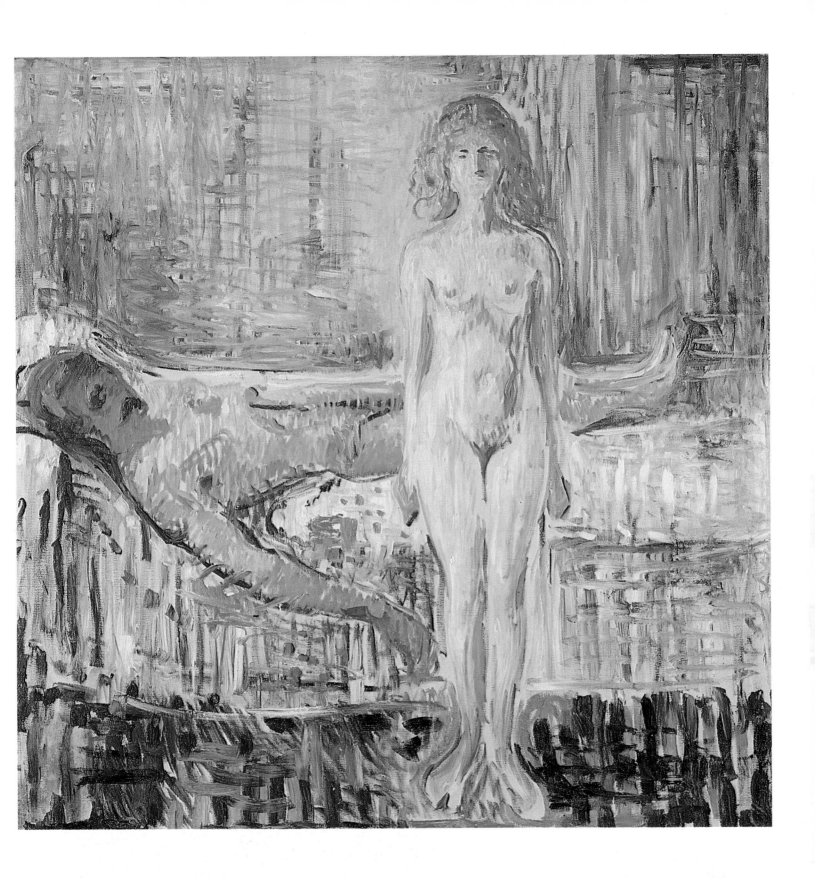

Men Bathing

1907-8. Canvas, 206 x 227 cm. Ateneumin Taidemuseo, Helsinki

Until the early years of the twentieth century, the subdued and often abject role played by the male in Munch's oeuvre predominates; man is usually a victim. It was the young German artists of Die Bruecke who dispelled the power of the *femme fatale*, from 1905, and replaced it with a frequently sexist hedonism. 'We lived in complete harmony, we worked and we went swimming. If we needed a model to set off one of the girls, one of us would leap into the breach' as Kirchner later wrote. Their great artistic hero, Munch, seems in turn to have adopted their youthful attitude in order to disperse symbolist gloom. Photographs show him painting on the beach with this work propped up behind him. From his German admirers Munch derived the splintery, almost glassy diagonal brushstokes prevalent here, suggesting the glare and pulse of sunlight and heat. The interplay of cool and warm tones charts the ambient temperatures of human bodies, shadows and the sea.

Several other works by Munch explore the male swimming or paddling, often with wry humour, and a few years later he was to develop such figures for the panels in the Assembly Hall at Oslo University.

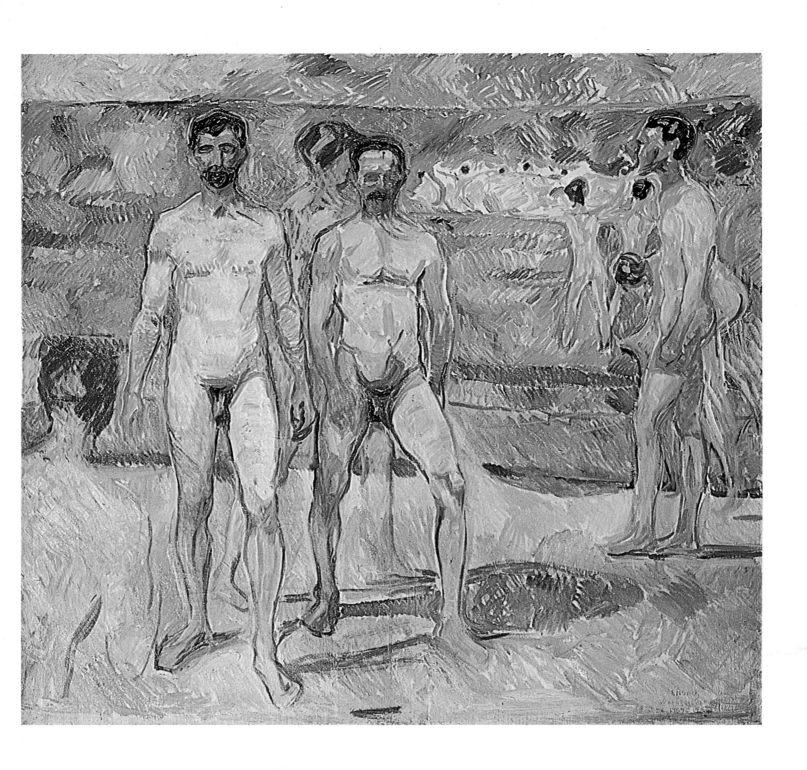

Life

1910. Canvas, 206 x 227 cm. Town Hall, Oslo

After his mental crisis and recuperation in Copenhagen in 1908, Munch returned to his homeland, although he travelled widely for the next twenty years. This work shows a new hard-won confidence which led him to produce large-scale allegorical works with overtly social and humanitarian themes for public display, a popular concept in Scandinavia at this time. *Life* is one of the first of these works. The *Ages of Man* theme is appropriate here and relates to the earlier *Three Ages of Woman*, while the familiar division of the sexes into light and dark forms is a late reflection of symbolism. The unnatural stance of the woman with arm upraised, on the right, is an unintegrated element in the composition and, as in the next plate, Munch obviously still felt ambiguous about the human presence in these allegories.

The allusion to ancient Scandinavian tree worship contrasts with the mens' sombre working-class clothing; a subject which concerned Munch increasingly after the university murals were completed in 1916.

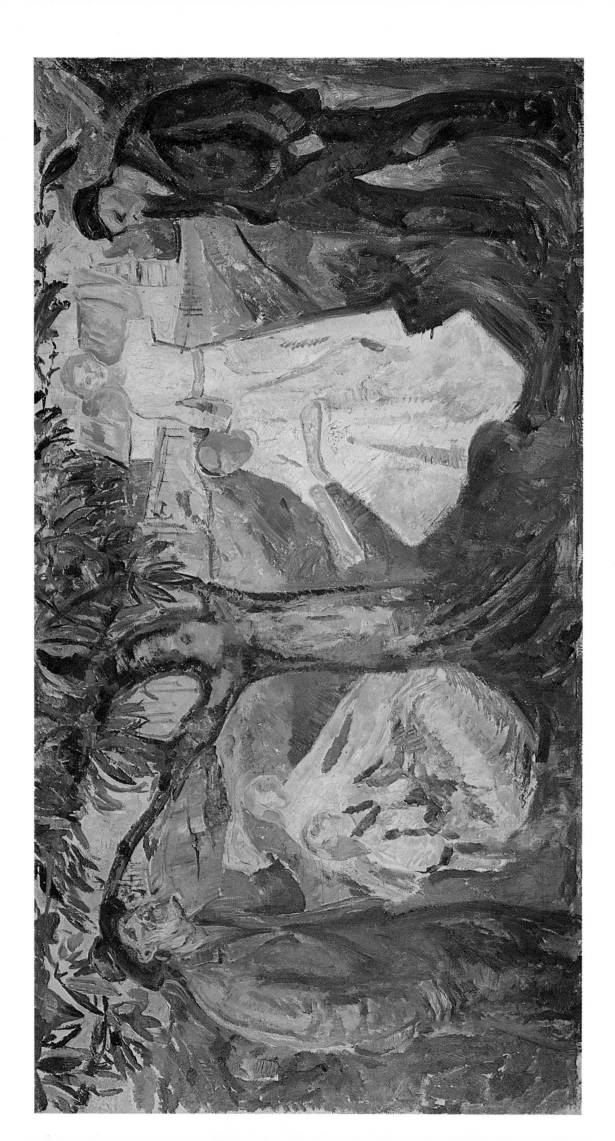

The Sun
(Central Painting of Oslo University murals)

1909-16. Canvas, 455 x 780 cm. University Assembly Hall, Oslo

It is difficult to do full justice to the grand ambition and inclusivity of Munch's designs for the 'Aula' (see Fig. 15). Realizing that the dry, matt tone of fresco had no place in a northern climate, Munch uses bright and lyrical colour with a marvellous vigour and confidence. He had intended to paint a 'montain of men', a towering pile of struggling humanity, shoulder to shoulder, aspiring to the sun (Fig. 29), but abandoned this as too much of a cliché and chose instead the more absolute emblem of the Nordic sun. The barbs and shafts of light have affinities with German Expressionism of a different kind than Die Bruecke; the more abstract and universal language of Kandinsky in the Munich Der Blaue Reiter. Hodler's Alpine visions are also evoked by the symmetry and centrality. Like Kandinsky, Munch is here both romantic and avant-garde, and the sun, indeed, is God.

Fig. 29
The 'Mountain of Men' in the Open-Air Studio at Ekely

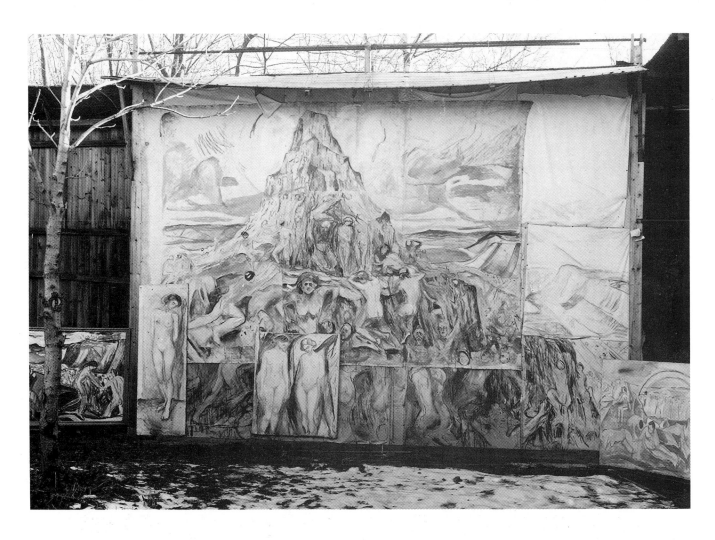

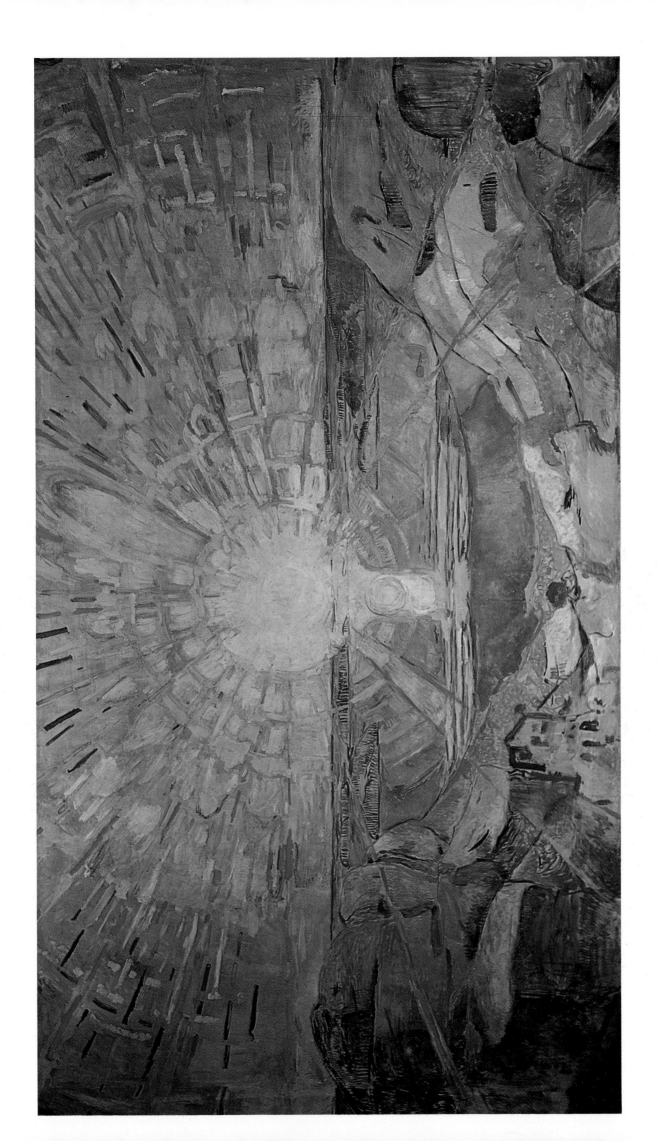

Sunbathing (Woman on the Rock)

1915. Woodcut, 35.1 x 56.6 cm. Schiefler No. 440. Munch-Museet, Oslo

The liberation of colour so amply expressed in the University murals was maintained by Munch in the following years. It is frequently subordinated to an earlier design, as in Plate 31, but always revitalizes it, and creates a new world that is less attached to observed reality. Munch's graphic work is protean; each pull of a print has its individual linking and coloration. These dominate the recumbent form on the sun-baked rocks in this woodcut, a wedge of orange jutting into the picture plane. The contrast of colour is loosely naturalistic – blue sky and green sea – but more important is the expression of sensation in the work, the rocks hot to the touch, the coolness of the feet dipping into the water. The psychological stress and strain of the 1890s is completely absent from this hedonistic view of nature.

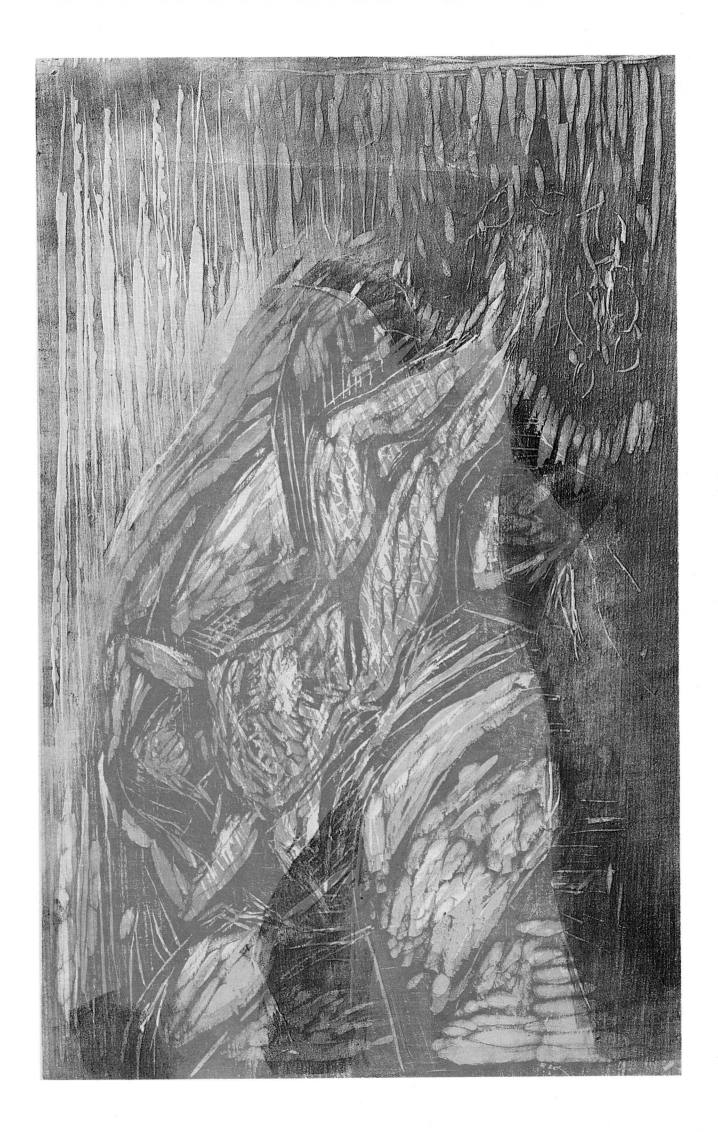

Workmen in the Snow

1912. Canvas, 136 x 195.5 cm. Munch Museet, Oslo

The worker's stolid forms are in contrast to the ghostlike creatures swarming along Karl Johan Street twenty years earlier. After lambasting the bourgeoisie, Munch's new-found public outlook led him to depict the working-class world, although he was not a romantic or political idealist.

Manet's *The Roadmenders* (Fig. 18) is the source for this painting, but Munch is more determined to portray specific workmen. They form a wedge, their shovels and legs creating an architectonic framework. Their exertion is apparent in their faces; the man on the right seems to rest on his shovel, while the smaller figures behind are working in the snow. A rough dignity and self-esteem radiates from the group, caught as though posing for a photograph, placing the work in the tradition of Millet (though without his sentiment) and Van Gogh (but without his intensity). The following year Munch made another version of the same subject (Fig. 30) in which the stark light-dark contrast is explored further.

Fig. 30
Diggers on the Road

c.1912. Lithograph,
43.5 x 61 cm.
Albertina, Vienna

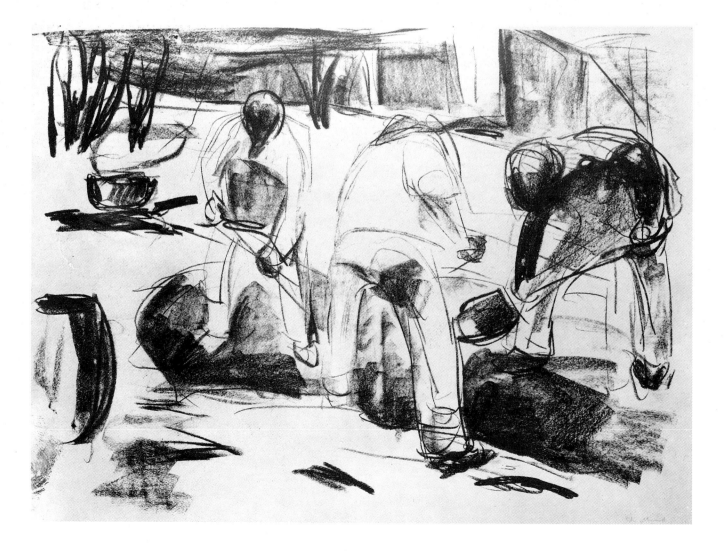

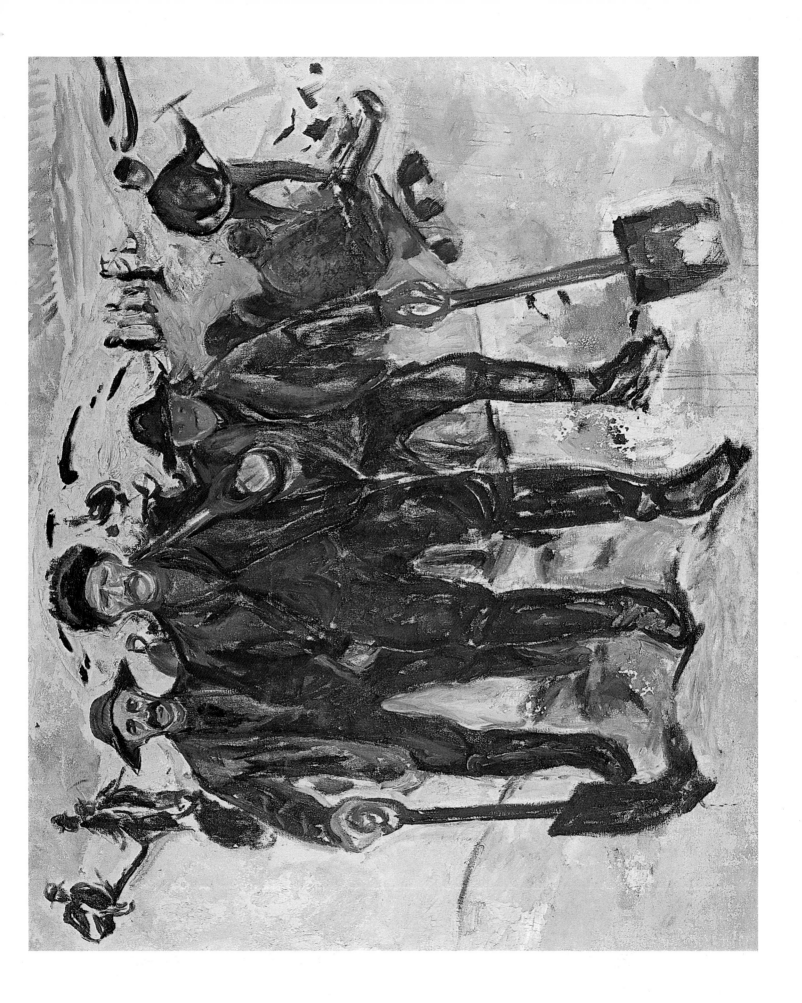

Man in a Cabbage Field

1916. Canvas, 136 x 181 cm. Nasjonalgalleriet, Oslo

As with many of the works Munch produced following the completion of the University mural, the full-frontal impact of the design is paramount in this painting. The triangular shape of the cabbage-gatherer, holding bundles of greenery in his arms, breaks through the horizon, his posture suggesting man's struggle against nature. The broad, raw colours, turquoise against olive-green, light purple against brown, and the rapid brushwork, separate the agricultural works from earlier urban paintings such as *Mason and Mechanic* of 1908, with its stark black and white contrasts. Munch completed the last such painting in the year before his death, and their importance was as a prophetic testimonial: 'the day of the workers is at hand', he wrote in 1929. Together with the more machine-oriented Léger he foresaw with enthusiasm an age of huge public murals, invoking a better life for the people.

Munch nevertheless maintains a deliberately down-to-earth approach in these depictions of the folk around Ekeley; this is no pastoral idyll. In this adaptation of Millet's famous painting *Sower*, Munch fought shy of the intense, visionary surge of colour and light that engulfs Van Gogh's adaptation of the same painting.

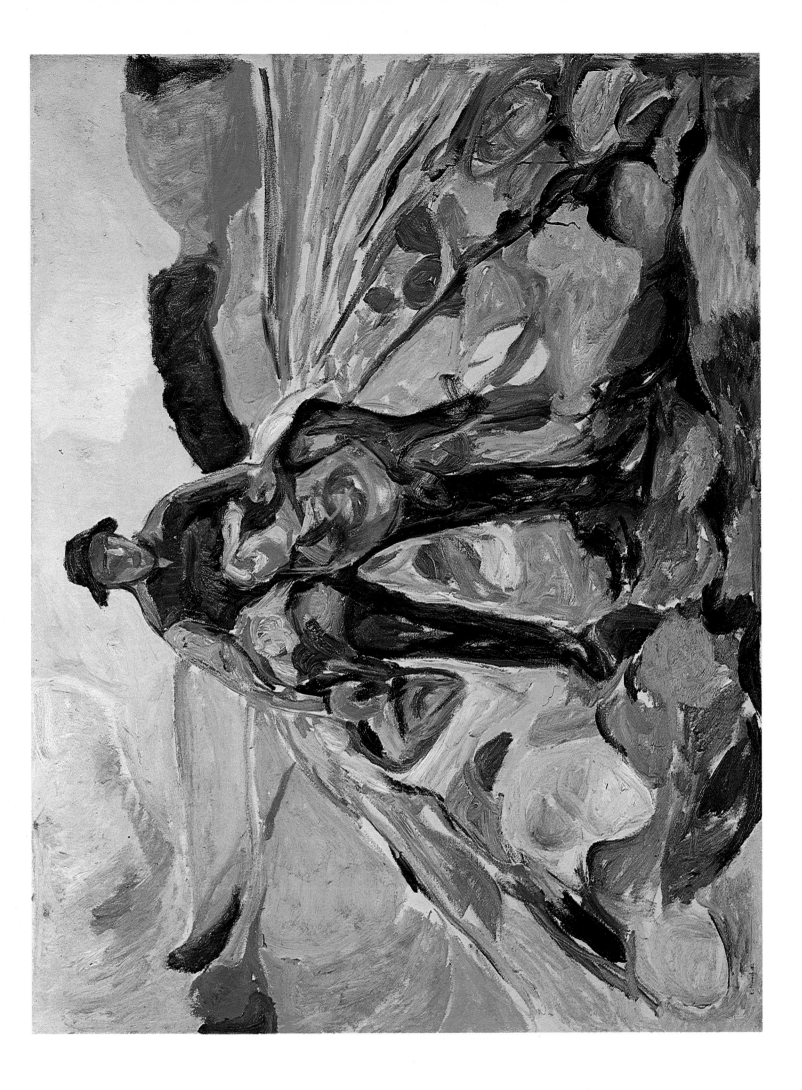

Horse-Team

1919. Canvas, 110.5 x 145.5 cm. Nasjonalgalleriet, Oslo

In this painting, as in *Ploughing (Two Horse Team)* of the same year and *Spring Ploughing* of 1916, an agricultural subject is rendered with the emphasis on the animals; the human element is reduced to a mannekin-like form giving distant guidance behind the steadily pacing plough-horses. The rich autumnal colours, and the rapid brush-strokes running in broad swathes towards the viewer, radiate a sensuous, almost tangible record of a specific occasion, however archetypal the activity. It is a mellow yet energetic painting, unlike the flurried depiction of equine panic in *Galloping Horse* of 1912, on which the composition of this work is based. The contrasting colours of the horses is a familiar Munchian motif, as is the way they seem to pull away from each other; both effects produce a necessary tension in the composition. But, instead of the anxiety present in the 1912 work, the sense of mutual control is predominant here, as man works in harmony with the seasons. The nature of rural manual labour is the real subject of this genre, while the creation of the murals in the Freia Chocolate factory a few years later would enable Munch to consider the nature of factory-based labour.

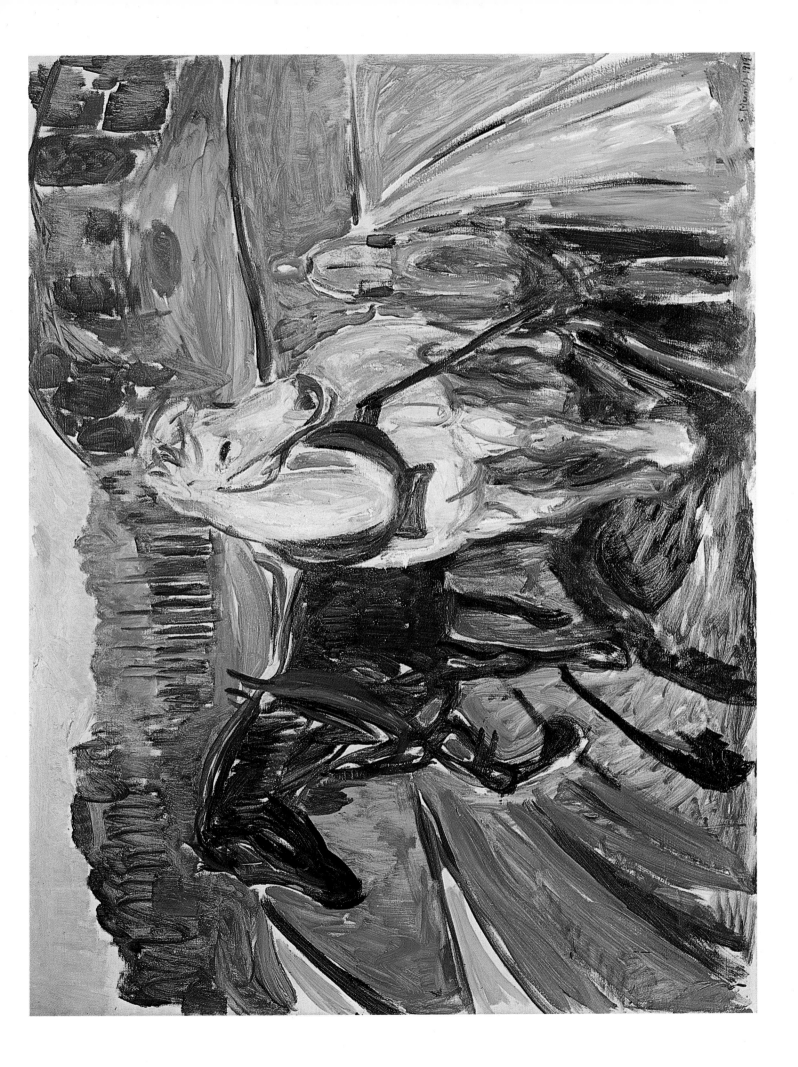

Starry Night

1923-4. Canvas, 120.5 x 100 cm. Munch-Museet, Oslo

Certain aspects of Munch's work after 1909 are in the nature of a reprise of earlier concerns and motifs (see Plate 31). This has often been interpreted as a diminution of his grasp and power, but *Starry Night* suggests otherwise. The source for the work is the 1893 nocturnal setting, shrouded in mysterious shadows, of the same title (Fig. 31). Munch painted many of variations of this subject, such as the nocturne *Moonlight*, the *White Night* of 1901 (Plate 35) with its similar high viewpoint, and *Winter, Kragero* of 1912. The presence of human figures in *Starry Night*, with their heads silhouetted at the base of the composition and their long shadows cast on the snow, adds a resonance not found in the other paintings. These elements are even more apparent in a charcoal sketch for the work, while the motif of the distant sparkling lights of the town occurs in a lithograph of 1920. The soft, bounding curves of the hedges leading towards the mushroom-shaped tree in the cleft of the slope, are parallelled by the band of shadow cast over the snow which channels our sight to the luminous horizon.

The work is often associated with Ibsen's *Johann Gabriel Borkmann*, and the foreground figures help to convey a sense of events unfolding that links the painting, for all its apparent benignity, with the psychodramas produced two decades earlier.

Fig. 31
Starry Night

c.1893. Canvas,
133 x 139 cm.
Private collection, Oslo

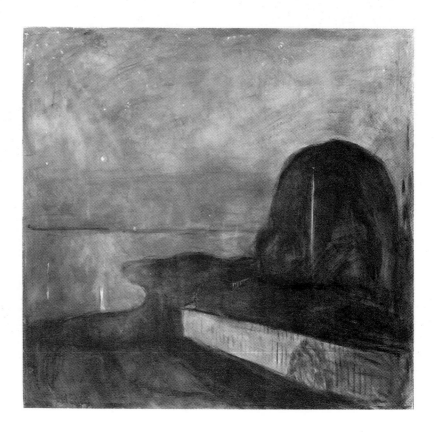

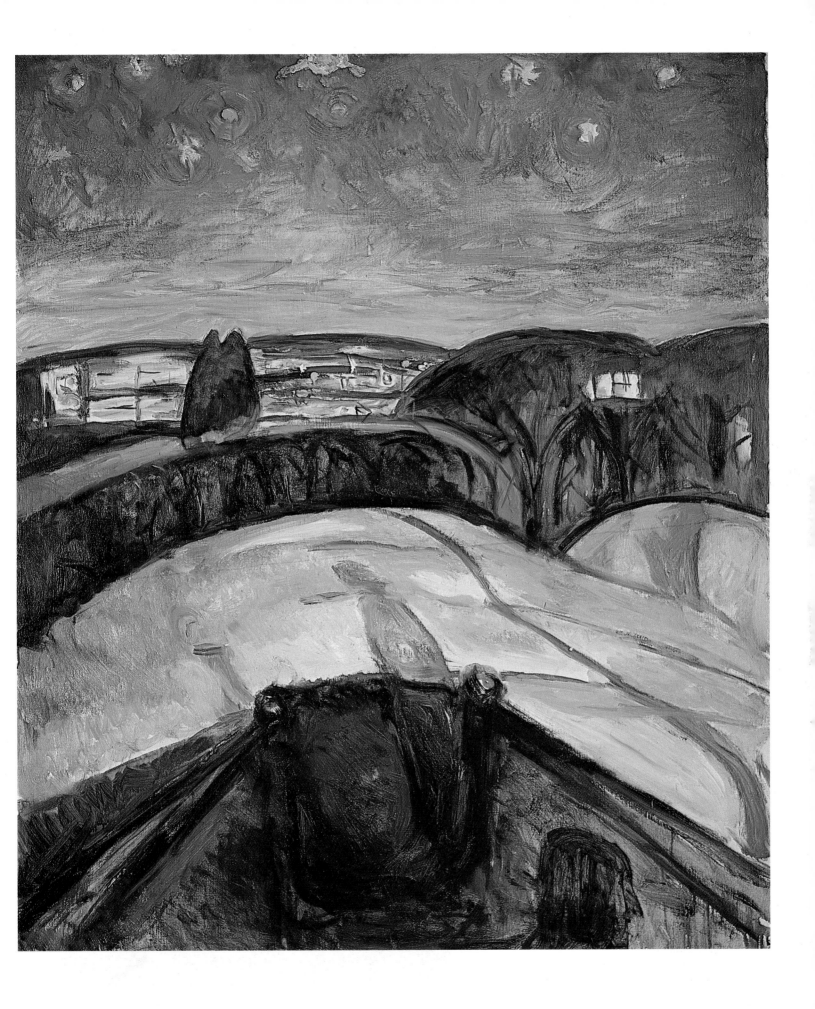

Nude by the Wicker Chair

1929. Canvas, 122.5 x 100 cm. Munch-Museet, Oslo

The traditional 'studio' format of this painting gained in popularity throughout Europe during the inter-war years, following the extremism of the Expressionists. *Nude Near the Bed* of 1907 was Munch's first painting to present the female nude without overt symbolic overtones (as in *Death of Marat*, Plate 38), but this work is more confident in its purely pictorial powers. This presentation is also evident in *Model on the Sofa* of 1928 and both works suggest the compositional influence, if not the colouring, of the School of Paris, Bonnard, and the *odalisques* of Matisse. Instead of their arabesque-based charm and expansive colour, Munch uses rich but raw tones as a draughtsman's tool. This earthy quality is reinforced by the blues and purples of the woman's flesh, and the vigorous handling is more reminiscent of Germanic artists such as Lovis Corinth and Kokoschka. This combination of contrasting warm and cool colours, which push and pull the picture space, and the model's slumped pose, give an objective grittiness quite alien to the mood of the preceding plate.

In the following year Munch was afflicted by eye trouble, forestalling his hopes of painting murals for Oslo Town Hall, and something of ill-health's disillusion, masked by vigour, permeates this work.

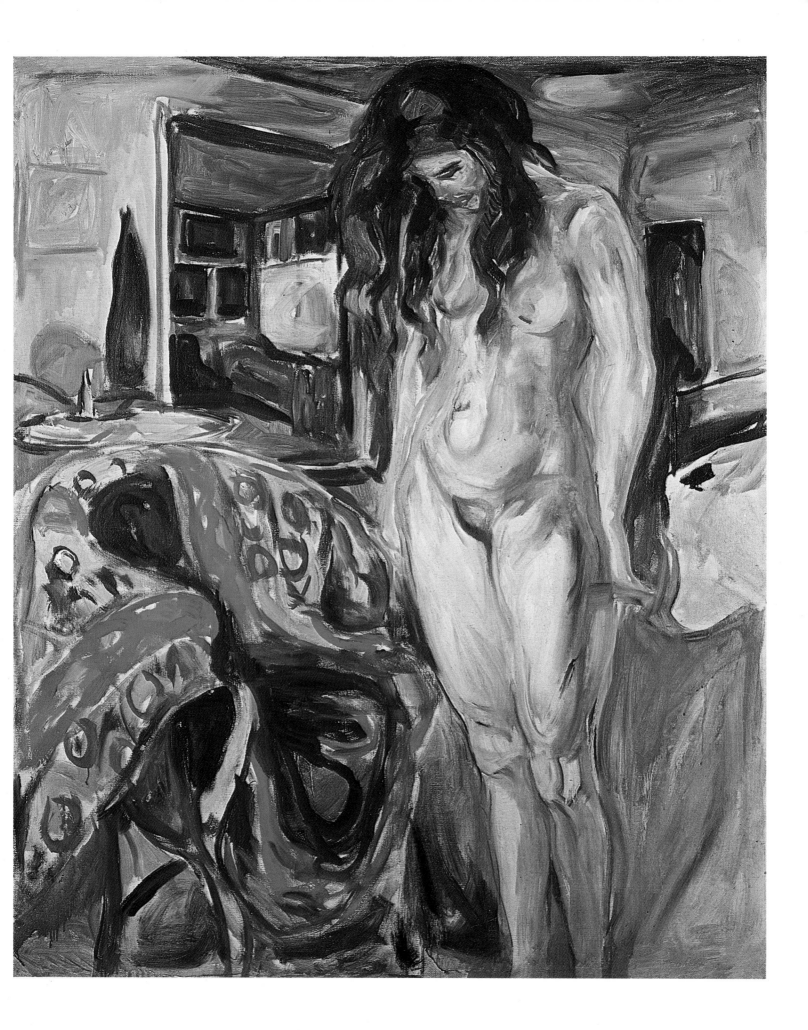

Gothic Maiden (Birgitte Prestoe)

1931. Woodcut, 59.6 x 32.1 cm. Munch Museet, Oslo

Fig. 32
The Trial By Fire,
illustration for
'The Pretenders'
by Ibsen

c.1927-31. Woodcut,
46 x 37 cm.

Birgitte, subject of the *Seated Model* of 1925-8, was Munch's main model in the last period of his life. He nicknamed her 'the Gothic Maiden' and in this woodcut exploits her long, elegant and rather melancholic face, resorting to a deliberately archaic presentation recalling sixteenth-century woodcut portraits. A similar work illustrates her as the heroine suffering ordeal by fire in Ibsen's *The Pretenders*, and both works have an unworldly, 'primitive' feeling to them. More subdued than the earlier expressionist-influenced woodcuts, with their flamboyant colours and vigorous carving, this woodcut reflects the post-expressionist era, in which calm and a 'new reality', after the mayhem of war, had been sought in many artistic circles and especially in the defeated Germany. The gentle nature of the sitter herself undoubtedly also influenced the execution. Unlike Inger, Birgitte does not stare directly out at the viewer but modestly across the picture space in the style of medieval religious figures, and instead of the somnolent, semi-conscious gaze of the *femme fatale* (see *Madonna*, Plate 22) there is an alert spirituality in her expression which is enhanced by the ascetic nature of the woodcut. It is a striking re-evaluation by the elderly Munch of his response to woman which was previously so ambivalent.

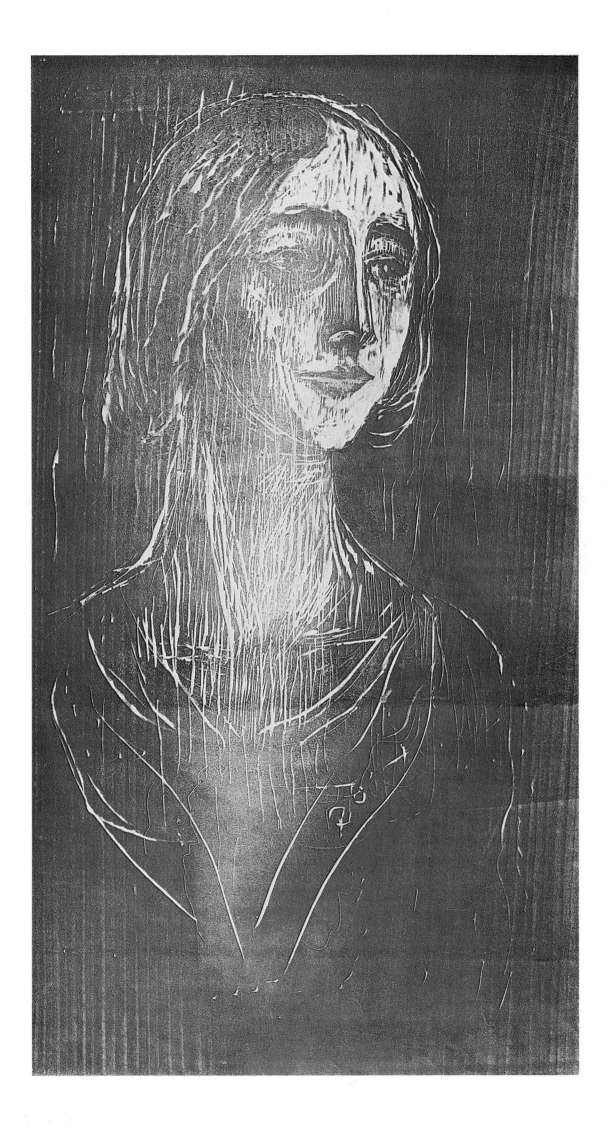

PHAIDON COLOUR LIBRARY

Titles in the series